The Dutch Table

GASTRONOMY
IN THE GOLDEN AGE OF
THE NETHERLANDS

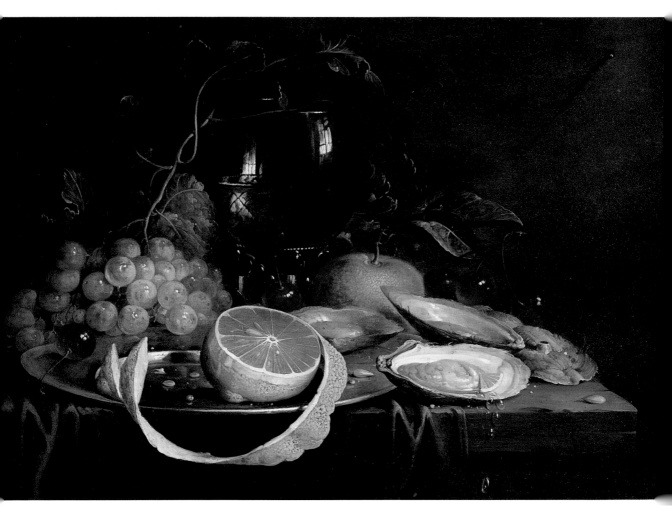

Jan van Kessel (1626-1679)
Still-Life. *Private Collection.*

Painters & Food

The Dutch Table

GASTRONOMY
IN THE GOLDEN AGE OF
THE NETHERLANDS

BY

Gillian Riley

Pomegranate Artbooks

SAN FRANCISCO

First published 1994 by Pomegranate Artbooks
Box 6099, Rohnert Park, California 94927

Conceived, designed, and produced by
New England Editions Limited
25 Oakford Road
London, NW5 1AJ, England

ISBN 1-56640-978-0
Library of Congress Catalog Card Number 93-87359

10 8 6 4 2 1 3 5 7 9

Editor/Art Director: TRELD PELKEY BICKNELL
Book Design: GILLIAN RILEY
Jacket/Cover Design: GLYNN PICKERILL
Typeset in Janson BY THE R & B PARTNERSHIP
Printed in Singapore BY IMAGO PUBLISHING

❧ Contents ❧

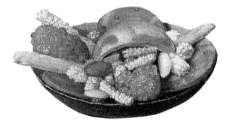

Introduction

THE PHRASE "Golden Age" makes a happy prefix to any of the recipes in this book. Golden Age Meatballs sound appealing, Dutch Rissoles rather less so. It is sad that the many good things to eat in the Netherlands today fail to get the credit they deserve. The cheeses, cured and preserved fish, pork products, and wonderful fruit and vegetables are as abundant and accessible today as they were in the markets and kitchen scenes which appear in the great Dutch paintings of three hundred and fifty years ago. But the traditions of cooking them seem to have changed. There is a diffidence about our native cuisine, in Holland (as in Great Britain and North America), which makes us cook "Italian" or "French" when wishing to please a special guest, ignoring our own gastronomic heritage.

The manuscript cookery notebooks used in Holland in the early seventeenth century, many of which traveled with their owners to settlements in the new World, were full of delicious dishes in a common North European tradition in which the comfortably off shared an affluent lifestyle that had more in common with members of their social class in other countries than their own peasantry or urban poor. The unsung heroines of this tradition are not the best-selling papal cooks or scholarly "foodies" of the Italian Renaissance but the anonymous, cheerful, self-sufficient housewives of comfortable bourgeois establishments, country estates, and modern town houses of Holland, or the pioneering settlers in New Netherland, that predominantly Dutch area between New England and the Chesapeake Bay region.

Later in the century, however, one of the most frequently noted differences between the Netherlands and the rest of Europe was how well the "middling sort of people" also lived and ate, with plenty of bread, meat, fish, and cheese. Household accounts from workhouses and universities show the generous amounts of meat, cheese, butter, and spices consumed by far from affluent communities.

The seventeenth century was also the Golden Age of genre painting in the Netherlands, when the celebration of the delights of peace and prosperity by artists found an enthusiastic market in that same "middling" class of citizens. John Mundy, an English visitor to Amsterdam in 1640 was impressed: "As for the art of Painting and the affection of the people to Pictures, I thincke none other goe beyond them. . . All in generall striving to adorne their houses, especially the outer or street roome, with costly peeces. . . "

A year later John Evelyn noted, with characteristic snobbery, how common farmers invested in paintings "to very great gains." The average weekly wage of a skilled worker in Amsterdam could buy a nice little interior (8 guilders), a fisherman on a herring boat could save up for an unattributed landscape (7 guilders), while a prosperous merchant could treat himself, in the late 1670s, to a more pricey Van Mieris at 800 guilders.

The gorgeousness of the wordly goods displayed in paintings depicting the interiors of private houses, public ceremonies, and still-lifes seems to reflect the enjoyment by an unrepentant population of the conspicuous consumption denounced by the preachers of a theoretically austere and self-denying culture. By no means all worthy citizens wore somber black and white clothing, and those who did spent lavishly on exquisite velvet and satin and intricate starched lace and linen, effective foils to their opulent jewelry and furnishings. It is pleasant to think of Marie de' Medici, the French Queen Mum, taking time off from her state visit to Amsterdam in 1638 for a characteristically hard-nosed shopping expedition.

Artists recorded an idealized version of all these good things, and often a moralizing comment on them as well, but what do the paintings of the time tell us about the way people ate? Do the recipe books confirm this? In some ways they seem to be describing very different worlds. Bread, ham, herring, and cheese make a fine basic meal at any time of day, an *ontbijtje* (see page 92) or snack, which can become—with the addition of butter, hothouse fruit, fine wines, and a few exquisite sweetmeats—a luxurious little meal. But recipe books never need to mention such basic things.

The cooked dishes which they describe do not, with the

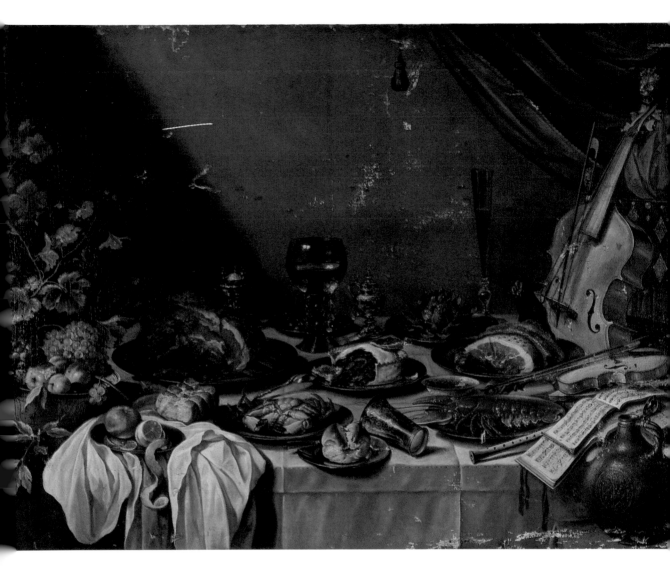

Pieter Claesz (1597/8-1661), Still-Life.
Wallraf-Richartz Museum, Cologne.

exception of pies, figure much in art. The sophisticated cookies of Clara Peeters and Peter Binoit would have been made by specialist pastrycooks (although we do find a set of instructions for making "letter cookies" in the *Volmaakte Grond-Beginzelen der Keuken-Kunde* of 1758). The enticing slow-cooked stews described in the cookery books, from humble *hutspot* (see page 91) to elaborate *olipodrigo*, are not as visually exciting as a fine side of beef, marbled with tasty fat, or a ham studded with cloves, in an embroidered crisscross pattern over its unctuous surface. Indeed, a saddle of hare, meticulously larded with thin strips of hard fat, demands the same skills that created the froth of lace worked by a Vermeer housewife. But the books assume that the reader will have all of these skills at her fingertips, and go on to describe a sauce without dwelling on how to achieve the perfectly roasted hare. The stuffed fowl, ready for the spit, with its skin spiked with cloves, or quills of cinnamon, can be the star of a busy painted kitchen scene or, done to a turn, will glow enthroned on a fine porcelain dish in a banquet piece. Yet how to achieve this rarely takes up more than a line or two in the cookery books.

The fruit and vegetable markets in paintings overflow with good things, from early spring to late autumn, all on the same canvas: young peas side by side with bletted medlars (see page 91) and parsnips (see page 92); strawberries from the New World— which were to overtake the tiny native wild strawberry—nestling up to autumnal pears and imported winter lemons.

Bunches of grapes abound. Held up by the stem, they symbolized both premarital chastity and fruitfulness in wedlock. They appear in a composition to highlight the ambiguities of a market girl's relationship with a rustic admirer or, crucially placed in a family portrait, to confirm the fecundity of a respectable bourgeois marriage. This does not mean, however, that they were ever a common cash crop.

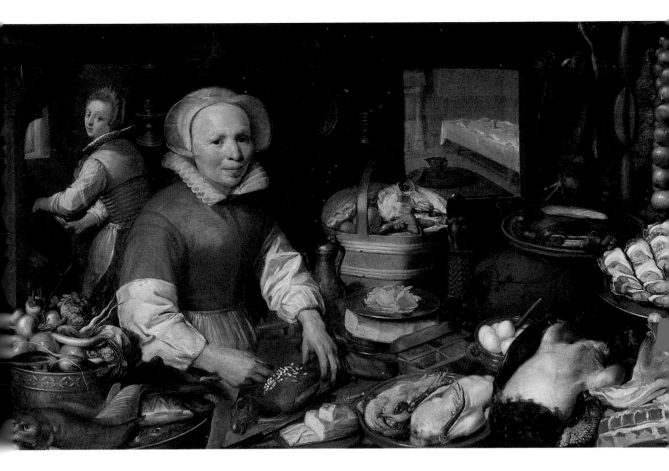

Amsterdam School (c. 1600), Preparation for a Feast. *The woman in the foreground is larding a hare, sitting placidly with her block of hard back-fat and larding needle. This will render the very lean flesh of the animal soft and succulent, a technique well worth using with a leg of lamb or a piece of calf's liver or turkey. If the fat is* spek, *cured bacon fat, or the strips are rolled in crushed spices, it is even better. Birmingham Museum and Art Gallery.*

Fruit, in earlier paintings of the Madonna and Child, had symbolic meanings understood by everyone, and this tradition of painting everyday objects both for their beauty and their hidden meaning was taken over by genre painters, who knew that most of their clients (unlike most modern viewers) were equipped by experience and education to understand and appreciate the interplay between representation and narrative, sensuous surface and disturbing interior.

This pursuit of symbols and hidden meanings in paintings is a most beguiling game, often toppling over into the higher lunacy. We must remember, as we heave and strain to uncover these portentous signals, that they were crystal clear to the painters and their patrons. Bible stories, proverbs, folklore, street wisdom, and old wives' tales all generated a stock of images and anecdotes that were then, but are not now, common currency. So a painting of a busy, down-to-earth kitchen or market scene could be appreciated on several different levels, as a record of the food and the way it was prepared, a show of pride in the prosperity that produced it, or as a complex moral commentary on modern behavior and its consequences.

The inn scenes of Jan Steen overflow with affectionate pictures of people, in their human frailty and sad disarray, having an innocent good time or getting themselves into quite a moral mess. Happy the food historian, who can walk away from the moral mess and enjoy the meticulous rendering of pots and pans, fruit and vegetables, pancakes, joints of beef, boiled lobsters exuding their rich juices onto oriental carpets, and overripe peaches deliquescing all over priceless lutes.

Or can we? This kaleidoscope of didactic and sensuous images cannot be viewed simply as a mirror held up to nature. The historian has to watch out for the anomalous appearance of things which are there because of some deeper significance. No one in their right mind ever let the juice of melons or freshly opened oysters dribble all over a musical instument whose cost and maintenance must have been like keeping a thoroughbred horse in the stable. It was allowed to happen in a painting in order to point a moral.

Onions and carrots have been interpreted as symbols of sexual depravity; the pouring of liquids from one vessel to another as

Pieter Brueghel, The Younger (c.1564-1638), Hamlet with Peasants Picnicking and a Couple with a Baby by a Stream. *Private Collection.*

unbridled lasciviousness. Yes, indeed. But throughout history countless women of quite blameless rectitude continued to cook with onions and carrots, and pour things in and out of jugs, regardless of their hidden meanings.

Huge pink and green cabbages can be symbols of fecundity and at the same time useful indications of innovations in market gardening. Walnuts strewn over a dining table can imply a succulent dessert or a complex symbol of Christ (the shell the wood of the cross, the nut the redeeming love of Christ for mankind). The guineafowl or ham larded with cloves (*nagel* means clove or nail) may be a sign of Christ nailed to the cross, or a nice insight into the use of spices.

13

The composition of so many still-life paintings can be an indication, perhaps unconscious, of the tensions within the society that produced them. Fruit about to roll off the edge of a table, a crystal goblet toppling to destruction from a dangerously tilted salver, a rich pie cut open, its fruity interior spilling over onto an immaculate white napkin, the fly polluting a slice of fresh white bread. Symbols of a society on the brink of dissolution or just a way of enlivening an otherwise static arrangement of objects?

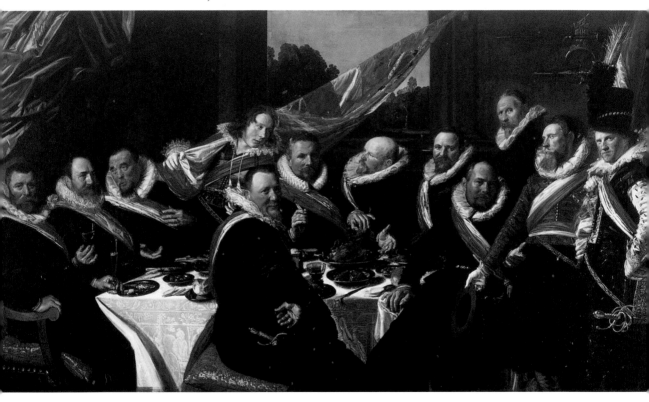

Frans Hals (1580/5-1666), Banquet of the Officers of the Militia of Saint George, Haarlem, 1616. *Copious quantities of traditional festive food and wine were consumed on these occasions, with elaborate rituals for carving, serving and the performance of toasts. The divisive presence of women, children, dogs, and religious discussion were all forbidden. Frans Hals Museum, Haarlem.*

The mellow autumnal glow that suffuses so many tranquil still-life paintings of the Golden Age implies a calm, independent nation at peace with itself and the rest of the world. Life seemed like "a perpetual Sunday," according to art historian Svetlana Alpers. This was an ideal rather than a reality, however, for the Seven Provinces of the Netherlands were embroiled with each other and occupying powers, involved in a continuous round of alliances and counteralliances, while at the same time building up a massive commercial superiority.

Sir Dudley Carleton was British ambassador to The Hague for some of this time, sending home detailed dispatches, and long, gossipy letters to his friend John Chamberlain: "Tilly's troops. . . have utterly spoiled and consumed the Landgrave of Hesse's country, where they have lodged ever since they left Westphalia. Mansfield's continue in much extremity in East Friesland, being afflicted at once with three sharp scourges, war, pestilence and famine. . . Cordoba's troops and Anholt's, joined together will be too strong for them, especially if they are forsaken by their French [mercenaries]. . ." And so on. If the tittle-tattle was so unfathomable, heaven help the recipients of the diplomatic bags.

What the paintings showed was that, in spite of external threats and mayhem, the people of the Seven Provinces were doggedly using their commercial clout to attain respite from violence and insecurity, creating pleasant towns and a peaceful countryside and using the ever-present threat of flood and invasion to point the stern Protestant moral that the enjoyment of prosperity was conditional on restraint from overindulgence in the good things it brought with it.

Simon Schama writes with engaging affection of this response by the Dutch to the conflict between enjoyment of their just deserts and the moral peril this could lead to. He sees in so many still-life and genre paintings the message that the achievement of the "just sufficiency" of the humanist preachers was a perilous undertaking. Warnings against the corruptions of an "overload" of luxury and splendor are beamed out from painting after painting. The very virtues which produced this wealth—thrift and industry—are in danger of being destroyed by the enjoyment of it.

But we can feast our eyes on the vehicles for these warnings, the paintings themselves, and our imagination on the glimpses they give into the daily lives of people we like and with whom we feel at home. Here now is a chance to share some of the unexpectedly agreeable food they cooked and ate.

A Word About the Recipes

There are two kinds of cook: those who, with elegant precision, execute the exact specifications of a recipe, with brilliant results and the anarchic, antiauthoritarians who take a recipe by the scruff of its neck and bash it about to construct from it, as it were, a plinth on which to erect a monument to their own culinary prowess, with an equally delicious outcome.

As in music, there is room for both approaches—you can be a Glenn Gould or a Trevor Pinnock. The challenge to us as cooks, is to reconcile information from paintings and recipes with what we imagine the food might have tasted like on the plate. Even with an authentic score and authentic instruments, musicians have to make an imaginative leap and guess what the music must have sounded like. We shall never know the precise taste of those glowing vermilion carrots or luscious fruit and meat pies, but inspired by literature and art, we can enjoy recreating our own versions of them.

The cookery books of the Golden Age were written for women who knew what was what, working within a sound gastronomic tradition, whose methods and quantities were understood and did not need to be spelled out. The recipes were narrative rather than prescriptive. To reduce the cheerful, hands-on prose of these recipes to the deadly, truncated gastrospeak of the home economist would be a literary and sensory crime. All good cooks adapt a recipe to their own inclinations. So translators and historians need to make that imaginative leap which fuses their own instincts with the painfully excavated meaning, word by word, of a text in its cultural context.

Here we have a selection of recipes which attempt to convey

the spirit of the paintings they accompany, in the light of what we can tentatively deduce about the eating habits of the time. Quantities, for what they are worth, are expressed in metric and standard imperial measures or cups. But they do need interpreting in the light of your own tastes and beliefs. Butter is specified "to taste" because some may wish to avoid it for health reasons and others prefer to pile it on for the hell of it. Garlic has to be a matter of personal choice; a stew may be liquid or dense; a salad vinegary or oily. Spices are used to suit the taste of the user.

Spices, in whatever quantity, do give an overall character to a period. The combination of sugar, cinnamon, and rosewater in Renaissance recipes is easy, and effective, to apply to roasts or stews. The Golden Age aromas are mace, nutmeg, and butter, with a tiny rasping of lemon or orange peel, with occasionally some ginger. Add them to a lightly cooked vegetable, like cabbage or asparagus, or to an apple tart or a batch of cookies, and you have an instant Golden Age effect.

The food of seventeenth-century Holland has all the virtues of its paintings, a generous warmth and wholesomeness with the subtleties of flavor and harmony that the "well-informed cook" brought to her kingdom—the kitchen.

GILLIAN RILEY, 1994

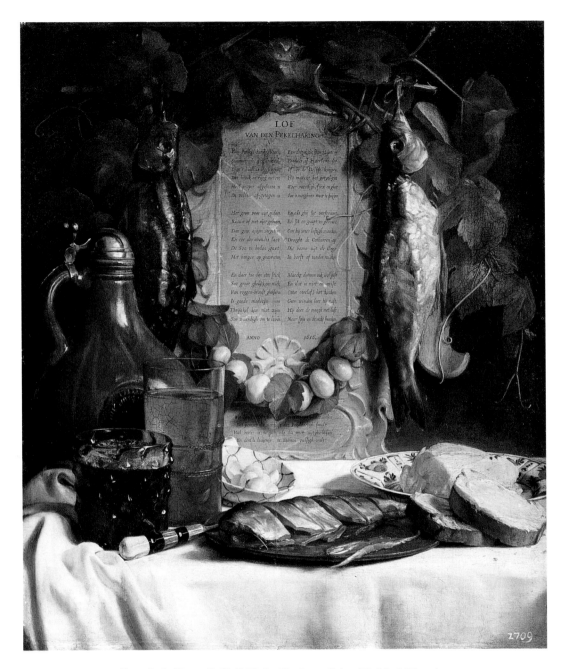

Joseph de Bray, Still-Life in Praise of the Pickled Herring.
Gemäldegalerie Alte Meister, Dresden.

In Praise of Herring

LIGHT PICKLED HERRING

"WELL, there's always herring . . . " they blushed and giggled. A group of distinguished Dutch graphic designers, asked point-blank to name the chief glories of their country's gastronomy, felt that the question needed to be rephrased. I insisted. Herring came a unanimous first. There then followed first a trickle, then a torrent, of childhood memories and happy reminiscences, from *oliebollen* to stewed red pears, delicious and unusual mixtures of ingredients and flavorings going right back to the Golden Age; every grandmother made them, but few visitors would even know they still existed.

"Green herring" is almost a tourist-brochure cliché—the distinguished Amsterdam businessman with impeccable raincoat and square-cut briefcase elegantly devouring a raw herring on the street corner, first dipped in chopped onion and held expertly aloft by the tail. The diplomatic wife in The Hague doing the same, neatly wiping her lips and fingertips, then patting down her smart suit and cycling off into the drizzle.

Groene haring (see page 91) are the best-loved herring products of the Netherlands. But even so they are not what they were, as the typographers pointed out; in the olden days these immature young herrings, around only at certain times of the year, before or after spawning, were cleaned as soon as they were caught, carefully retaining the gallbladder (which contains an enzyme that enhanced the bacteriological action which produced their special flavor), then submerged in a mild brine solution and eaten the following day, skillfully skinned and boned but retaining the graspable tail. With a cure so mild, and with all the ongoing bacterial activity, these special young herrings needed to be eaten straight away.

Modern refrigeration techniques have destroyed this classic

procedure, and with it the highly unpleasant *nematodes* (see page 91) which lurk within the almost-raw fish. So technology has transformed the product but, on the whole, to our advantage—freezing kills them off.

Earlier methods of curing produced a more durable pickled herring. Salted, dried, smoked, in various combinations, the herring was cheap and plentiful. It sustained the Dutch navy during the long sea voyages which were the foundation of Holland's commercial supremacy; it triggered off several wars; was a significant export and, above all, formed the best part of the well-balanced diet of the greater part of the population.

So it is hardly surprising to come across a set of rather banal verses in praise of this fine, popular food. Written by the Remonstrant preacher Jacob Westerbaen (poet, doctor, and friend of Constantijn Huygens) and incorporated by Joseph de Bray in his *Still-Life in Praise of the Pickled Herring*, painted in Haarlem in 1656, the verses praise the succulence and the laxative and diuretic properties with uninhibited gusto while neatly describing how the herring should be prepared and eaten.

It begins:

> *A shiny pickled herring*
> *Corpulent, thick, and long,*
> *Its head chopped off,*
> *Its belly and back*
> *Sliced neatly,*
> *Its scales scraped.*
>
> *Its guts removed,*
> *Eat raw or fried,*
> *And don't forget the onion.*
> *And before the Sun*
> *Sets in the evening*
> *Devour with relish.*

Vacuum-packed frozen *maatjes haring* (see page 91) made up for export can be bought all over the world but are quite different from the ephemeral *groene haring*. *Maatjes* are best eaten simply, sliced and served on a plate with finely chopped mild raw onion. Incorporated in a salad with chopped apple, celery, gherkins,

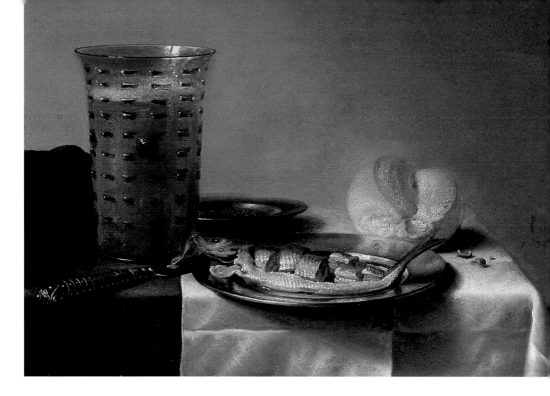

Pieter Claesz (1597/8-1661), Ontbijtje.
Museum Boymans-van Beunigen, Rotterdam.

and the anachronistic potato, they begin to lose the fine elemental simplicity which is celebrated in countless austere "breakfast pieces."

This pride in the basic staple food of the Republic—herring, cheese, and bread, washed down with wholesome beer—glows in the deliberately monochrome *ontbijtje* (snack) paintings and their antithesis, the *pronk* (swank—see page 92) set pieces, with their equally proud celebration of all the good things in which a wealthy trading nation could afford to indulge.

The humble herring holds its own among imported delicacies and lush hothouse fruits, fine French wines, and exquisite Venetian goblets. Willem van Aelst, "the aristocrat of still-life painters," in his *Breakfast Piece* of 1680, gives the herring, bread, and onions a polished, sophisticated aura which must have both delighted and reassured his patrons.

Light Pickled Herring

Buy the freshest possible herring from a good fishmonger, otherwise this recipe will be a disappointment and a waste of time.

> 4 fat fresh herrings
> 2 tablespoons salt crystals
> 1 tablespoon sugar
> Fresh dill, thyme, or fennel, finely chopped

Get the fishmonger to gut, scale, and fillet the herrings, leaving them whole. Lay them in a flat glass or enamel dish. Put half the sugar and salt inside each fish and add the herbs. Close up the herrings and put the rest of the salt and sugar on top. Cover with a sheet of film and a plate, pressed down with a suitable weight. Leave in the refrigerator overnight or for a full twenty-four hours.

To serve, take the herrings from their pickling liquid, dry, and slice thinly on the diagonal. They are best eaten simply with chopped raw onion, and washed down with well-chilled *jenever* (see page 91).

Willem van Aelst (1623-1683), Ontbijtje, *1660. The Burrell Collection, Glasgow.*

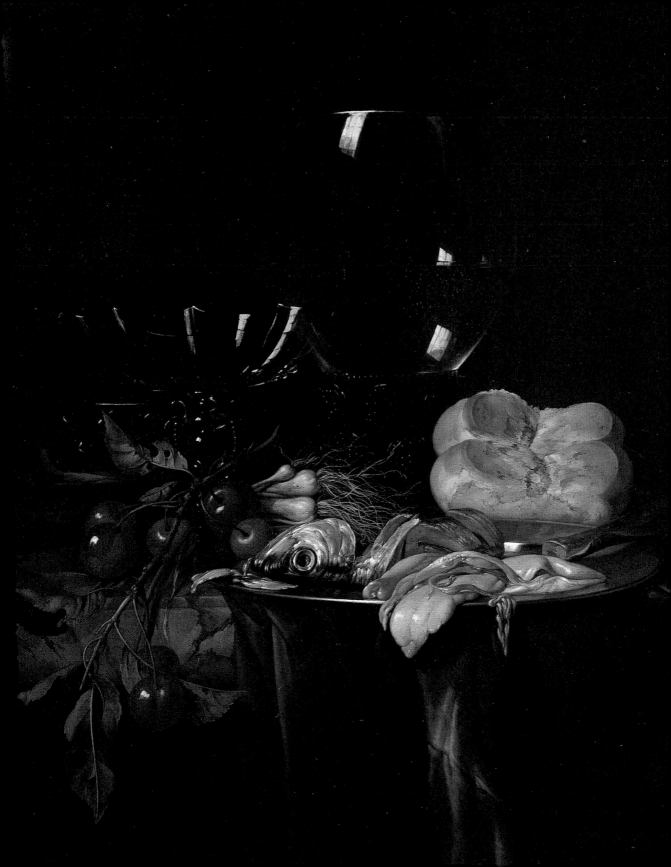

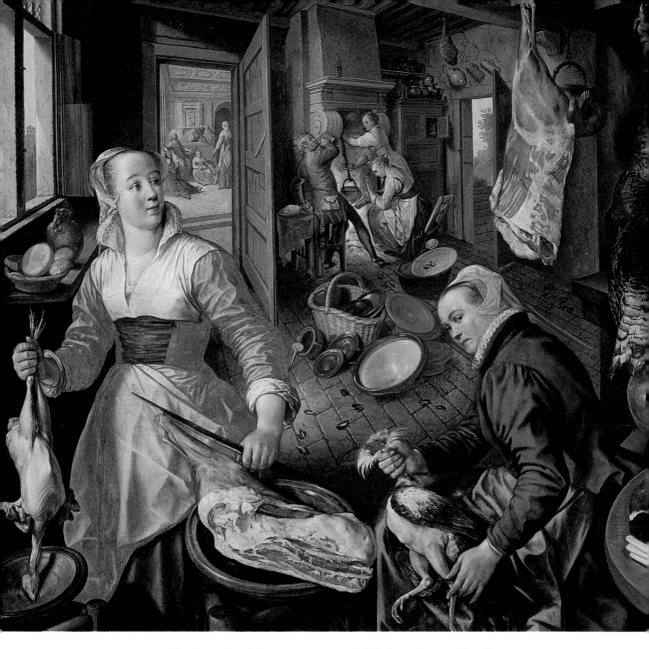

Joachim Beuckelaer (1533-1573), Kitchen Scene *(detail)*,
1570. Museum of Fine Art, Ghent.

Kitchens Sacred & Profane

CHICKEN WITH ORANGE

STEWED CABBAGE

BUTTERED PEAS

WHAT COULD be more pleasing than the cheerful bustle of a prosperous family kitchen? A profusion of good things, fresh produce from the estate and market stalls, amid the ordered confusion of a busy but well-regulated household. The fresh-faced, decorously dressed cook and housemaid prepare the poultry and meat while the master of the house converses with friends in the lofty, paneled room beyond.

This idyllic domestic scene is, nevertheless, a far from tranquil picture. It is a disturbing painting, but difficult at first to see why. Little details, like the newly slaughtered duck dumped on the exquisitely laundered napkins, or the *berkemeier* goblet rolling inexorably off the table onto the tiled floor, do not alone explain the tensions. Beuckelaer's insistent perspective, however, draws us into another dimension. The diagonal lines of the composition all lead to a vanishing point in the far room on the left, focusing on the person of the master of the house who, on a closer glance, is to be seen (complete with halo) expostulating with the irritable, hyperactive housekeeper, while her sister sits smugly at his feet. This is Christ in the house of Martha and Mary, a painting with a moral, not an everyday picture of ordinary folk. Our pleasure in the lavish ingredients and anticipation of the meal to come is rebuked by the message that the costly fuss and bother of the meal should be rejected in favor of the contemplation of more spiritual matters. Disturbing indeed.

Chicken with Orange

Meat and chickens were roasted over an open fire with stews suspended over it in a great pan, while smaller pots could cook at different temperatures in the embers.

This recipe is a way of serving a chicken which was first part-cooked on the spit.

For four people:
6 or 8 chicken pieces
1 bitter (Seville) orange (see page 91)
2 glasses dry white wine
Sugar, cinnamon, mace, salt, and pepper to taste
Butter to taste

Fry the chicken pieces in butter until golden but not cooked through. Meanwhile peel the skin off the bitter orange, carefully avoiding the white pith, and cut into thin strips. Simmer these in a little water until just soft, taking care not to boil away the flavor. (You can omit this process for a more pungent effect.)

Add the white wine to the chicken in the pan and stir into the cooking juices. Add the orange peel and mace and simmer, uncovered, until the pieces are tender and the liquid has reduced. Taste and season with sugar, salt, and powdered cinnamon.

This is not a sharp-tasting dish. It should be fruitily aromatic and mildly spiced. Garlic and bay leaves are a pleasant addition.

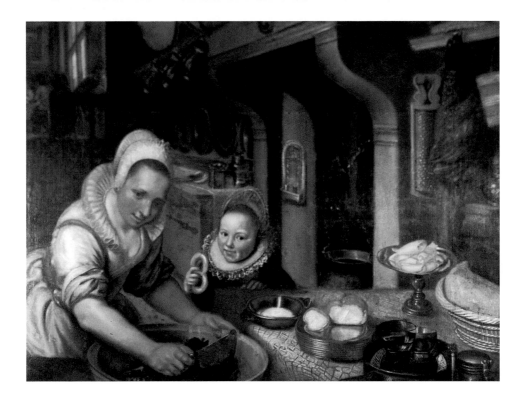

Attributed to Joachim Beuckelaer, Dutch Kitchen. *Here we have a cheerfully secular painting, without a religious message, though the child's pretzel, or* krakeling, *could have provided the pretext for a little homily on the moral education of the young. The characteristic shape of this ancient bread or biscuit may signify hands at prayer, might have been a talisman to ward off the devil and, to seventeenth-century parents, was certainly meant to signify the conflict between good and evil inherent in all little creatures.*

The massive grater hanging up on the right would have been used not just for cheese but to make breadcrumbs from stale loaves and to grind up cooked pork liver for dishes like the Rustic Meatballs (page 64). The other ingredients are being chopped in a big tub by the little girl's mother. Courtesy of The Berkshire Museum, Pittsfield, Massachusetts, gift of Zenas Crane.

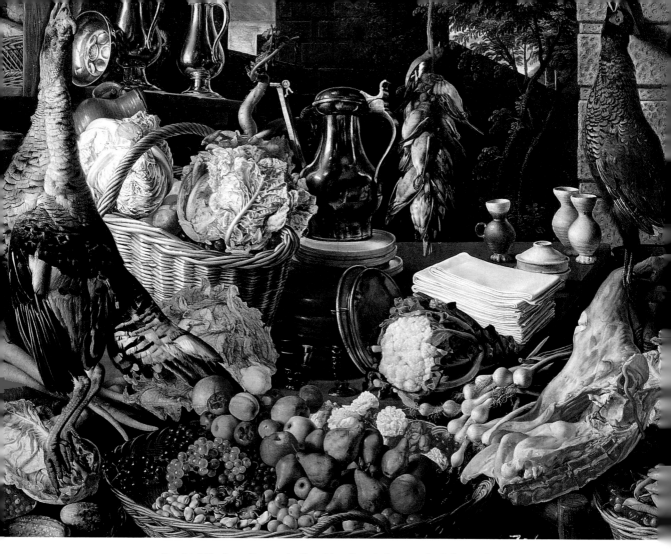

In this Kitchen Scene *by Joachim Beuckelaer in the Mauritshuis,
The Hague, the voluptuous array of provisions has quite ousted the
Bible story which might have been the pretext for the painting. The
warm evening light casts a calm and untroubled glow over the
mounds of fruit, vegetables, and fowl. This idealized survey of a
well-stocked kitchen offers the earliest spring delicacies—wild
strawberries, peas, broad beans, and scallions—alongside autumnal
medlars, cabbages, and nuts. The exotic delicacies, such as
asparagus, artichokes, and large strains of strawberries from the
New World, are not yet to be seen.*

❦ Stewed Cabbage ❧

For four people:
1 head of cabbage
2 cups strong homemade stock
Garlic to taste
Salt, freshly ground nutmeg, mace,
 and black peppercorns
Butter to taste
The yolks of 2 hard-boiled eggs, crumbled

Cut the cabbage into quarters and slice away the stem. Chop coarsely and put in a pan. Cover with a little water and bring to the boil. Drain.

Return to the pan, add the stock and seasonings, and cook until tender. Then enrich with as much butter as you dare, and sprinkle the egg yolks over it as a decorative garnish. Adjust the amount of stock to give a soupy or dry dish according to taste.

❦ Buttered Peas ❧

Mange-tout and sugar-snap peas are some of the many kinds of peas originally developed by Dutch market gardeners, this recipe preserves all their delicate freshness.

For four people:
2 lb. (1 kg) sugar-snap or mange-tout peas
1/2 cup butter, or more
1/2 cup finely chopped parsley
Salt and pepper to taste

Trim the peas of any stalks and string them. Rinse and cook in a large, shallow pan with just the water remaining on them. Add the butter when they seem to be dry and go on cooking until done, neither squeaky *al dente* nor mushy. Stir in the parsley and serve at once.

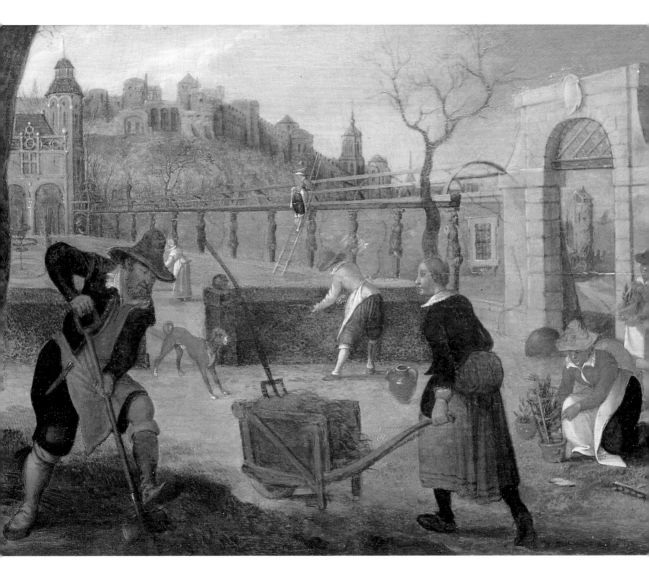

Attributed to Sebastian Vranckz (1573-1647), Gardeners at Work in a Formal Garden. *Private Collection.*

The Country House Kitchen

THREE WAYS WITH ARTICHOKES

A MIXED SALAD

CHICKEN WITH HERBS & MEATBALLS

FREE FROM the stifling constraints of monarchy and aristocracy, the "new" money of the Dutch Republic was spent cheerfully and prudently on elegant town houses and country estates. Fortune untrammeled by rank purchased homes of considerable comfort, and vast fortunes bought parkland, lawns, and vistas, and—most important—vegetable gardens and farmsteads. The kitchens of these new estates were bright, airy rooms with a brand-new modern invention in one corner—the stove.

Handbooks of estate management were published for the instruction of these newly rich householders. One of these, *Het Vermakelijck Landt-Leven*, included a cookbook specially written in 1667 for the country house kitchen: *De Verstandige Kock* (*The Sensible Cook*, as it is always translated, a somewhat dreary name for a collection of exquisite recipes). Perhaps *The Well-Informed Cook* would better convey the mixture of intelligence, common sense, and experience required in the careful housewife placidly concocting fresh, light little dishes in an existing Dutch tradition but using the sophisticated produce of the most enlightened gardeners of Europe and the new technology of the custom-built ceramic stove.

This stove, with its even, controllable temperatures and slow, gentle heat, was innovative. Slow-cooked dishes have always been around, congealing, or boiling over, in the uncertain embers of wood and charcoal fires. But here we have a way of making several small, gently simmered recipes to perfection.

The title page of *The Well-Informed Cook* has an engraving of one of these modern kitchens, with the pretty tiled stove on the left, an open fire with spits and a cauldron on an adjustable chain in the center, and a baker's oven to the right—the ideal kitchen for a self-contained rural estate.

The town houses of the same rich families had equally sophisticated kitchens, but the menus would have depended on the produce of market stalls and shops. The old ways of cooking lived on, though, even in these modern kitchens, together with the comfortable staples of cooked meats, cheese, and bread, always at hand for meal or snack. It was a matter of pride that in the Netherlands even the humblest family could afford a sufficiency of decent fare.

Clara Peeters (c.1583-c.1657) sums up the subtleties of the new cuisine in this still-life, with fresh fish, artichokes, prawns, langoustines, and a colander of salad herbs and greenery embellished with bright borage flowers. Private Collection.

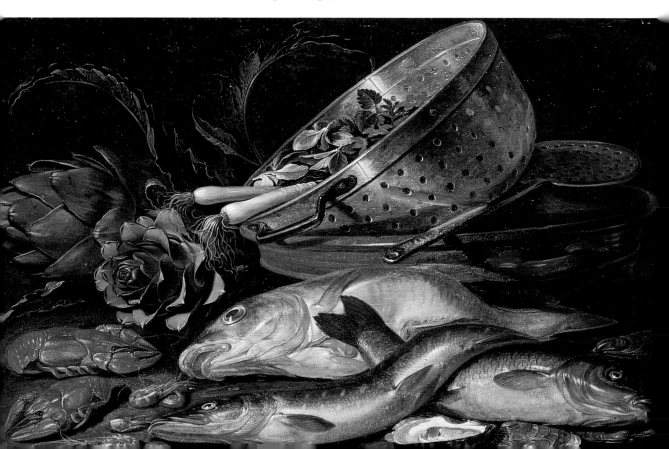

❧ Three Ways with Artichokes ❧

Baby artichokes were eaten raw, as in Italy today, the choke and the inedible parts of the leaves cut away and the hearts sliced and eaten with salt, pepper, oil, and vinegar.

The prepared hearts of more mature artichokes were simmered in a mixture of stock, dry white wine, breadcrumbs, and butter; seasoned with salt, pepper, mace, and nutmeg; then enriched with butter.

Whole artichokes were cooked until done, the leaves discarded, the chokes removed, and the hearts finished in a buttery sauce thickened with stale breadcrumbs soaked in dry white wine, mashed to a smooth consistency and flavored with vinegar, salt, pepper, mace, nutmeg, cinnamon, and sugar.

❧ A Mixed Salad ❧

Our country-house cook had a wealth of salad greenery at her disposal and a mixture of the following, when in season, was dressed with salt, oil, and vinegar, or with melted butter and vinegar: hearted lettuce, the leaves of romaine or cos lettuce, curly lettuce, lamb's lettuce, young dandelion leaves, wild chicory, chicory shoots, endive, red and white cabbage, and cucumber. Optional were cress, catmint, purslane, salad burnet, rocket, tarragon, and a scattering of edible flowers—buttercups, bugloss, borage, along with rose and marigold petals.

🐚 Chicken with Herbs & Meatballs 🐚

This is a refreshing break with tradition—a delicate, slow-cooked stew, without the rich spiciness of the medieval tradition but brilliant with an unusual combination of greenery.

For six people:
1 medium-sized free-range chicken, cut into pieces
4 oz. (125 g) bacon or *pancetta* (page 92), all in one piece
1 cup each of chopped sorrel, celery leaves or lovage,
 cos lettuce leaves, asparagus tips and stalks
Salt, pepper, and garlic to taste

For the meatballs:
8 oz. (25 g) finely minced fatty pork
½ cup of chopped parsley
1 teaspoon grated lemon zest
½ cup fresh white breadcrumbs
1 egg
Garlic, nutmeg, mace, salt, and pepper to taste

Mix the meatball ingredients together and form into little balls the size of a walnut. Roll in flour and keep on one side.

Simmer the chicken pieces with the bacon in a little water until almost done. Add the meatballs and simmer for 15 minutes more. Check the amount of liquid; the sauce should not be too runny. Take out the bacon and cut it into small pieces. Stir in the greenery. Cook, covered, until the potherbs are just done, then take off the lid and tip in plenty of butter. Taste for seasoning and add salt, if necessary, and pepper.

This can become a low-fat dish by skinning the chicken pieces before cooking them and adding just a little butter at the end. The meatballs and bacon can also be less fatty if you wish.

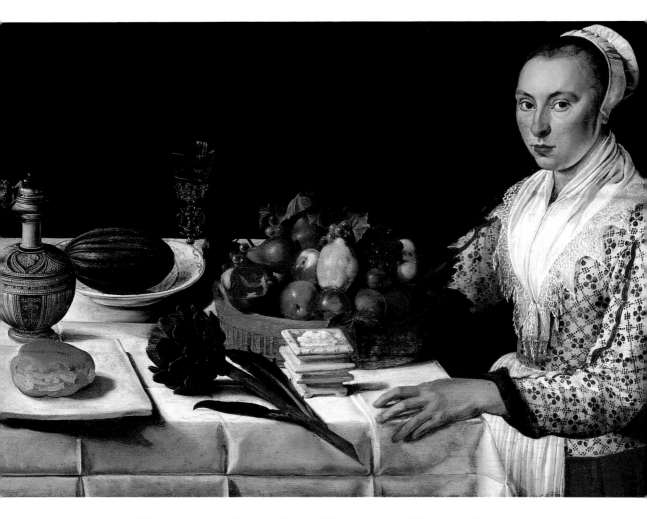

Decorative as well as intelligent, this seriously sensible housewife displays the refinements of her domain—beautifully laundered linen, fine white bread, a Venetian wineglass, and a basket of hothouse fruit, a melon, and fine big artichoke. Flemish School, Still-Life with Young Girl. *Collection of The Montreal Museum of Fine Arts.*

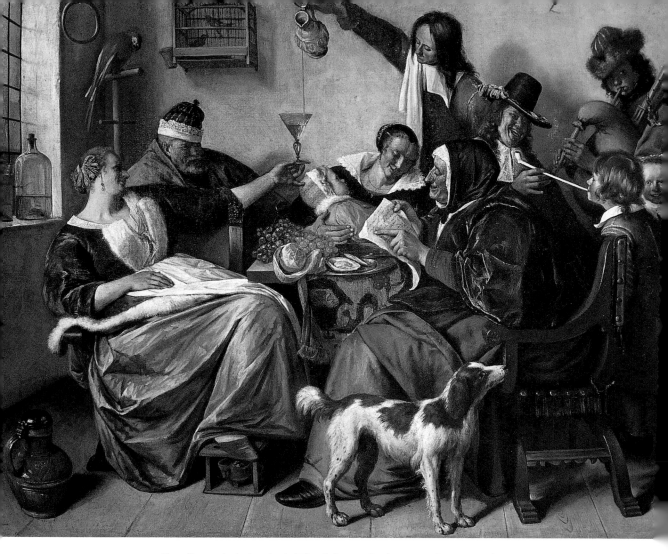

Jan Steen (1626-1679), The Merry Gathering. *On the surface a happy family party, three generations enjoying themselves together, with grandfather playing the "Lord of Misrule" and even the tiny baby joining in. As in many of Jan Steen's paintings, indications of virtue or vice are built into the composition, and here we have the faithful dog, the watered wine poured by a sober servant, a little music denoting domestic harmony, and the literate granny. Steen was an innkeeper himself and had plenty of experience of tavern life; his affectionate record of scenes of merriment sometimes included a portrait of himself joining in the fun. The father offering a pipe to his small son may be a self-portrait, and may, indeed, carry just a hint of the dangers of overindulgence. Perhaps the moral is to take the painting at its face value and enjoy this as a scene of straightforward domestic cheerfulness. The Mauritshuis, The Hague.*

Happy Families

DELICATE MEATBALLS

BITTERBALLS

APPLE CUSTARD CRUMBLE

APPLE PIE

STEWED EELS

THE CHEERFULNESS of Dutch domestic life sometimes astonished foreigners. An uptight French visitor was taken aback when his host praised his wife's cooking with gusto and got a smacking kiss in return. Whether it was the unexpectedly good meal or the public display of affection we don't know, but this was before French manners and French gastronomy took hold in the Netherlands, when wives were often shrewd business partners, not elegant possessions, and ran their homes and families with efficient precision.

When Constantijn Huygens, cultivated man of letters and scientist, wrote some verses to his young wife, Susanna, he abandoned poetic rhetoric and praised her, not as a nymph or goddess, but as a Dutch housewife. His *Daghwerck* records the daily round of their life together, just as painters celebrated the everyday events of a household—combing a child's hair, sweeping the floors, preparing food, playing a tune on the harpsichord, taking a glass of wine with a visitor, copying out a recipe, or enjoying a frolic on Saint Nicholas's Eve. Mellow afternoon sunlight picks out the red skirts and rosy cheeks of this careful housewife, protected from the autumnal chill by an elegant, fur-lined jacket and a nice warm fire, over which the *hutspot* (see pages 53 and 91) simmers gently. The apples might have been used in some of the delicious dishes described in *The Well-Informed Cook*.

Delicate Meatballs

This subtle family recipe, using mildly flavored ingredients—veal rather than pork, exotic lemons and bitter oranges, delicate fresh herbs, and the mild spices, nutmeg and mace—is typical of the light country house cooking of comfortably off families.

For four people:
1 lb. (500 g) fatty leg of veal
1 cup fresh white breadcrumbs
1 cup finely chopped parsley
1 egg
Freshly ground nutmeg and crushed mace to taste
Salt and pepper to taste and garlic if wished
1 teaspoon each of grated bitter orange
 (see page 91) and lemon peel

Cut the meat and fat up very fine, add all the seasonings and egg yolk, and mix well together. Roll up into little balls and then cook in various ways:

1. Roll in flour, dip into beaten egg white, and poach in stock. Remove after 20 minutes and finish in hot butter. Serve with lemon juice.
2. Fry in butter or olive oil until golden brown and eat hot or tepid.
3. Once fried, simmer in a little stock and wine until the liquid is almost absorbed.

Modern street food in this tradition, the ubiquitous "croquettes," can be delicious or not, depending on the ingredients and quality of oil used. Better by far to sit down in a nice bar or café with a portion of *bitterballen* (see page 91) and a glass of good beer or a shot of young or old *jenever* (see page 91).

The affectionate cheerfulness of many Dutch marriages is happily conveyed in Frans Hals's wedding portrait of Isaac Massa and Beatrix van der Laen in 1622. Their country estate is seen in an idealized, Italianate rendering in the distance. The Rijksmuseum, Amsterdam.

Bitterballs

Stew 1lb. (500 g) of shin of beef with some finely chopped onion and aromatics (see page 91) until really soft. Pound to a paste in a pestle and stir the mixture into a stiff béchamel sauce. Chill thoroughly and then make into little balls about the size of marbles. Roll each one in flour, dip it in beaten egg, then roll it in breadcrumbs and fry in a good quality grapeseed oil until brown and crisp. Drain and serve very hot with a blob of mustard.

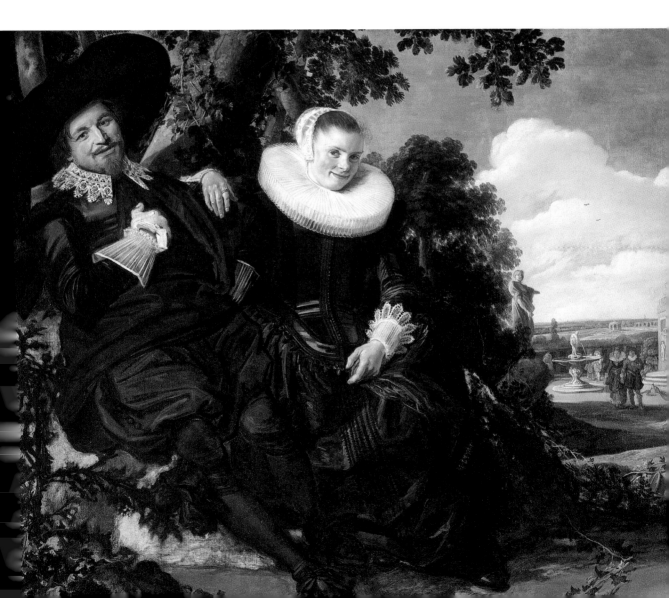

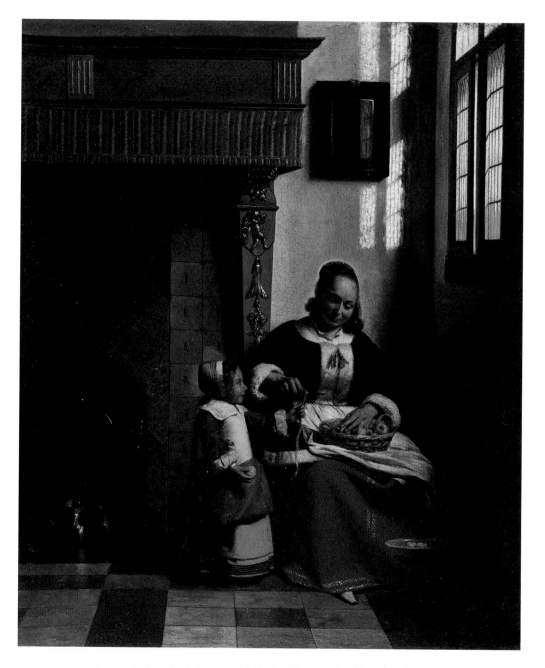

Pieter de Hooch (1629-c.1684), A Woman Peeling Apples.
The Wallace Collection, London.

🎕 Apple Custard Crumble 🎖

4 tart, well-flavored apples (Coxes or Reinettes)
2 beaten eggs
2 cups dry white breadcrumbs
2 to 3 cups sugar
2"(5-cm) stick of cinnamon
butter to taste

Pulverize the cinnamon and one cup of the sugar in the coffee grinder and mix with the breadcrumbs.

Peel, core, and slice the apples. Cook them slowly in a shallow pan with a lump of butter and sufficient sugar to sweeten to your taste. When soft, add the eggs and stir until the mixture thickens.

Heat half the remaining butter in an ovenproof pie dish. When it foams add half the breadcrumbs and cook till crisp. Then put the apple mixture over this base, cover with the rest of the crumbs, and dot lavishly with butter. Bake in a hot oven until the top is golden and crunchy.

🎕 Apple Pie 🎖

Rich shortcrust pastry:
8 oz. (250 g) flour mixed with ½ cup sugar, 1 cup butter, 1 egg, and a pinch of salt. Work the butter into the flour and sugar and mix in the egg. Let it rest in a cool place, then roll out.

For the filling:
2 lb. (1 kg) apples, peeled, cored, and thinly sliced
1 cup sugar
1 cup currants
1 teaspoon freshly powdered cinnamon
1 teaspoon crushed anise seeds
1 cup butter

Melt the sliced apples in a little of the butter in a heavy pan.

Line a deep pie dish with half the pastry.

Put in layers of apple, currants, sugar, and spices until the dish is full, with generous lumps of butter over each layer of apples. Cover with a pastry lid, make a few holes in the lid, and bake in a moderate oven until done.

Stewed Eels

London's Eel and Pie shops are flourishing survivals of old traditions of popular street food. At its best, this is nourishing, tasty stuff, comforting fare for cold shoppers and busy market people. The eels are stewed until tender in aromatics, including whole allspice berries, and served in a sauce, called "liquor," made with the cooking juices and fresh parsley. This sauce is the gravy for the homemade meat pies which are eaten on the same plate with the eels and a generous dollop of mashed potatoes.

Eels were a popular food in the Netherlands as well; even when technically at war, the British and the Dutch were trading cargoes of eels and herring regardless of hostilities. To solve the problem of getting the freshwater eels to customers alive and in good condition, they were transported in the bilges of ships, cunningly adapted to that purpose.

Eels are fine, fatty creatures and need a sauce which counteracts their soft richness, like the aromatic liquor of the pie shops. This old Dutch recipe works well with whatever fresh herbs are to hand. A modern version uses sage instead of the lovage and parsley.

For six people:
2 large eels, skinned, cleaned,
 and cut into bite-sized pieces
1 large onion, finely chopped
1" (25-mm) piece of fresh ginger, grated
Salt and pepper to taste
1 cup chopped parsley
½ cup chopped lovage

Stew the eels with the onion, ginger, salt, and a little water. When they are tender, add the herbs and a lump of butter, and cook until the herbs are softened but have not lost their fresh color. Add salt and pepper to taste and serve with plain boiled rice or on slices of good bread fried golden in butter.

An eighteenth-century version of this recipe uses dry white wine instead of water, omitting the ginger.

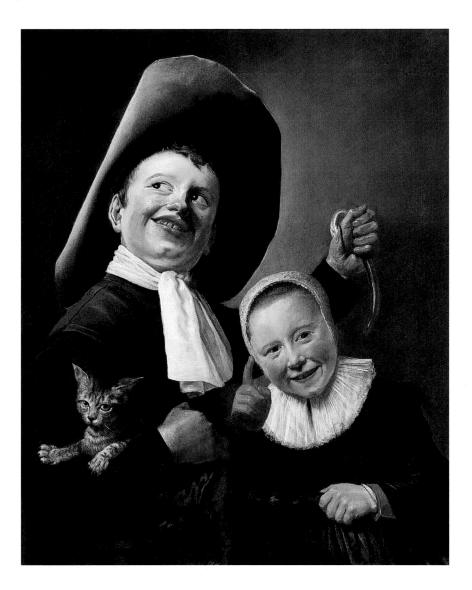

Judith Leyster (1609-1660) probably used her own children as models for this terrifying pair. As a portrait of mischievous youngsters it stands on its own, but to seventeenth-century parents it carried many messages. The eel and the cat were immediately recognizable symbols of sexual depravity; the children are thus making a knowing comment on adult misdemeanors. The National Gallery, London.

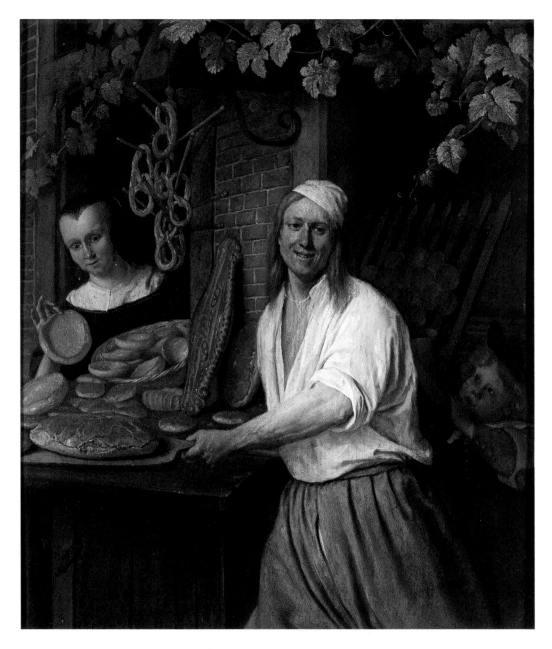

Jan Steen, The Leiden Baker Arent Oostwaard
and his Wife Catharina Keizerswaard, *1658-1659.*
The Rijksmuseum, Amsterdam.

The Perfect Partnership

BROODJES (PLAIN WHITE ROLLS)

BREAD, until its tragic eclipse by the dead hand of the potato (see page 89), was presented as the ideal partner for the ham, cheese, and herring in countless Dutch still-life paintings and was always part of more elaborate meals and banquets in the form of white rolls, *broodjes* (see page 91), or more complicated rusks and fancy bread. Bakers and pastrycooks made several batches a day, each announced by a blast on a horn.

This double portrait immortalizes what was obviously a perfect partnership. The blousy, charismatic young baker, flushed with the heat of the oven and a conscious pleasure in his own prowess, is watched over by his neat, buttoned-up little wife delicately proffering a friable rusk, with pursed lips, calculating eye, and the lurking suspicion of a much-needed sense of humor—the ideal combination of cool business brain and creative flair.

Bread is still the best accompaniment to the superb cheeses, fish, and pork products of present-day Holland. Unfortunately, the modern *broodje* can be a national disgrace, a pallid wodge of tasteless, textureless white fluff, unworthy of its splendid antecedents. To be fair, the great tradition of fine baking, which flourished in the European "wheat belt," is continued in the breadmaking of immigrant communities, and fine Turkish and Arab bread can be enjoyed with Dutch cheeses and fish.

❧ Broodjes (Plain White Rolls) ❧

1 lb. (500 g) strong white flour
1 teaspoon dried yeast
Salt to taste
Good olive oil or butter to taste
Water, hand hot

Dissolve the yeast in a little water and leave in a warm place to work for a while. Sift the flour into a heated bowl. When the yeast is nice and frothy, make a well in the flour and put in the yeast, olive oil or butter, and the salt, dissolved in tepid water. Mix with enough water to make a firm dough and knead for ten minutes or so. Cover with a cloth or plastic sheet and leave to double in bulk, about an hour.

Punch the risen dough down and form into rolls, carefully tucking the edges of the dough underneath, to make a compact little ball that will not "unwind" as it rises. Flour the undersides of the rolls and lay them on an oiled baking sheet. Leave to double in size.

Bake in a very hot, preheated oven for 5 to 10 minutes.

This basic method can be varied in many ways. The addition of a little sugar, caraway or dill, or poppy seeds gives a very different flavor. The rolls can be glazed with a mixture of cream and egg yolks just before they finish cooking. They can be slashed with a sharp knife when they are ready to go into the oven to produce a patterned effect, or plaited or twisted into decorative shapes.

Pieter Claesz, Still-Life with Roemer, Bread Roll, Olives, and Nuts in a Pewter Dish on a Stone Ledge. *Private Collection.*

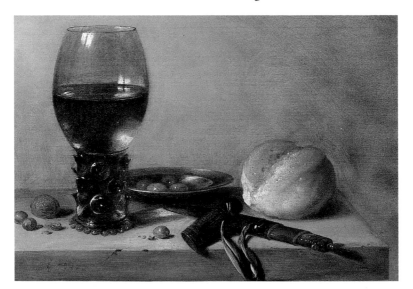

The Apotheosis of Milk

♣♣♣♣♣♣♣♣♣♣♣♣♣♣♣♣♣♣♣♣

SAVORY CHEESECAKE

SWEET CREAM CHEESECAKE

♣

PAULUS POTTER'S portraits of cattle combined a thoroughly professional understanding of husbandry with a dreamy, poetic sense of the voluptuousness of their fresh milk, satiny cream, and mellow, golden butter. The modest little milkmaid is quite eclipsed by her numinous beasts, cherished as the source of so many gastronomic delights.

The commercial Edam and Gouda of our supermarkets, pallid interiors virtually indistinguishable in taste and texture from their lurid plastic coatings, give no idea of the wonderful variety of Dutch cheeses still made today. An "Old" Gouda, similar in density of taste and texture to Parmigiano Reggiano, can be used in the same way, grated and added as a condiment, or added to other, softer cheeses to give a depth of flavor, or eaten at the end of a meal, in thin slices, with wine. The sweetish aftertaste of some of these elderly cheeses makes them a good match with a Montbazillac or aromatic dessert wine. The greenish brown goat's cheeses which often top the pile get their dense flavor and color from the animal's droppings in which they are matured, which help both the bacterial activity and the flavor.

Cheeses spiced with cumin, cloves, or caraway seeds are for eating (not cooking) in thin slices, with good bread and honest beer. The costly "cheese stack" of so many still-life paintings, occasionally topped with a fine china dish of butter, indicates a level of wealth, even ostentation, that could be made to point a moral, highlighted by the odd insect or mouse, that this accumulation of edible capital might topple over from frugal snack to gluttonous self-indulgence.

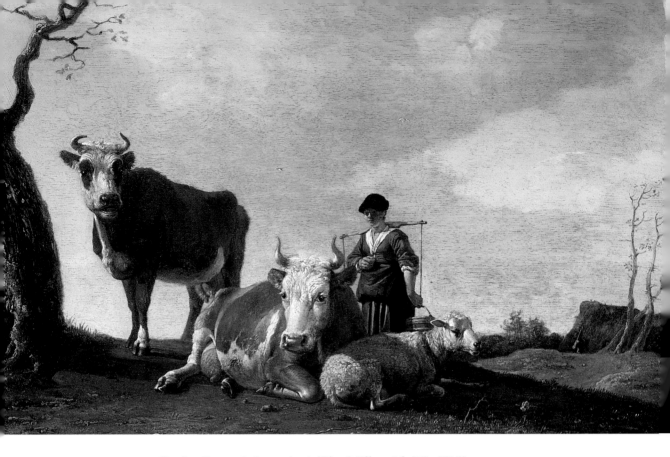

Paulus Potter (1624-1654), The Milkmaid. *The Wallace Collection, London.*

Zuivel op zuivel
Is't werk van de duivel

Cheese with butter is an evil
Wished upon us by the Devil

was a smug and oft-repeated saying to the effect that eating butter and cheese together was a sinful extravagance. There must have been enough of it about to cheer the devil and justify the appearance of so many china dishes of butter perched on piles of cheeses.

But recipes using cheese are surprisingly rare in seventeenth-century Holland; tarts and pies, which in Italy would have had ricotta and parmesan, were enriched with butter and eggs. The exquisite tart in Clara Peeters's painting might have been the

cheesecake from *The Well-Informed Cook*, or perhaps the cream and rosewater version. The decorative sprigs of rosemary would have been an aromatic addition to the design, but also pointed a moral. Rosemary, for remembrance, was a reminder that earthly pleasures, like cheesecake, were vain and ephemeral things, no sooner eaten than forgotten, spicing our enjoyment of this rich spread with a little frisson of guilt.

Savory Cheesecake

Quantities are engagingly vague in many of the recipes, assuming enough experience on the part of the cook to follow a suggestion rather than a set formula.

> *Here is my version of a simple cheesecake:*
> 2 cups rich cream cheese
> 4 egg yolks
> ½ cup butter
> ½ cup white flour
> Salt, pepper, and nutmeg to taste
> Rich shortcrust pastry (see page 41)

Line a shallow tart case with the pastry and bake until done.

Mix the flour with a little milk and beat into it the egg yolks and seasonings. Add the cream cheese and beat until smooth.

Cook slowly over a low heat until the mixture thickens. The flour is to prevent it curdling but you still need to take care. Pour into the pastry case and bake in a moderate oven until golden. Eat warm or tepid.

The addition of chopped fresh herbs and some freshly grated parmesan is pleasant.

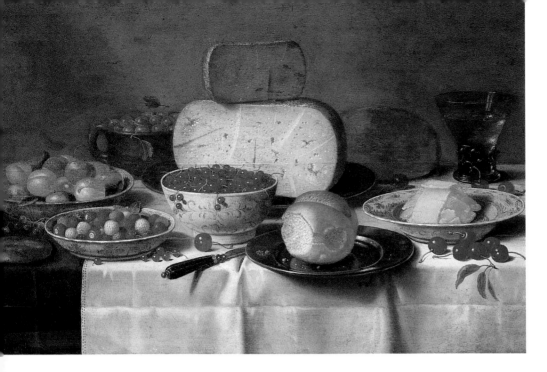

Floris Gerritsz van Schooten, Still-Life with Fruit and Cheese. *Some old and young cheese, bread, butter, and fruit—basic food, portrayed with all the trappings of luxury.*
Private Collection.

Sweet Cream Cheesecake

> 1 pint (575 ml) rich, full cream
> 4 egg yolks
> ½ cup rosewater
> ½ cup flour
> ½ cup sugar, or more, to taste
> Rich shortcrust pastry (see page 41)
> Cinnamon to taste

Line a tart case with the pastry and bake until done.

Mix the rosewater and egg yolks and beat the flour into it until smooth. Add the cream. Cook the mixture over a gentle heat until it thickens. Perfume with cinnamon if desired. Pour into the pastry case and bake slowly until done, but not colored. Decorate the surface with a pattern pricked with a fork, and garnish with sprigs of rosemary.

50

Clara Peeters, Still-Life. *We do not know if this collection of exquisite confections reflects Clara's sweet tooth or that of the patron who commissioned the painting, but they appear to be the work of professional pastrycooks. The delicate cookies might represent the ephemeral nature of earthly pleasures, while the wedding rings and sprigs of rosemary for remembrance indicate more lasting delights. Courtesy of Charles Roelofsz Gallery, Amsterdam.*

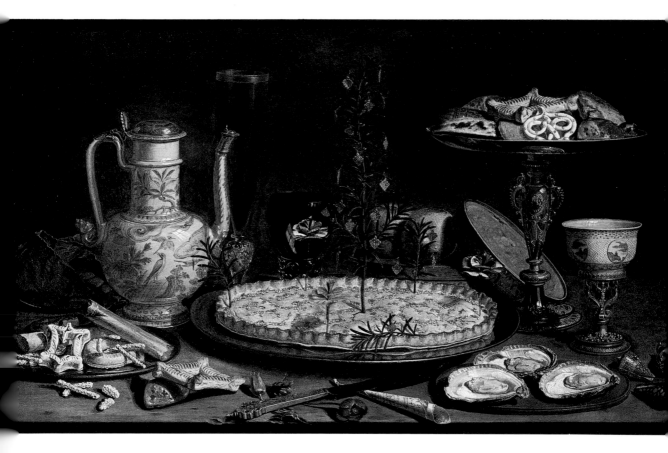

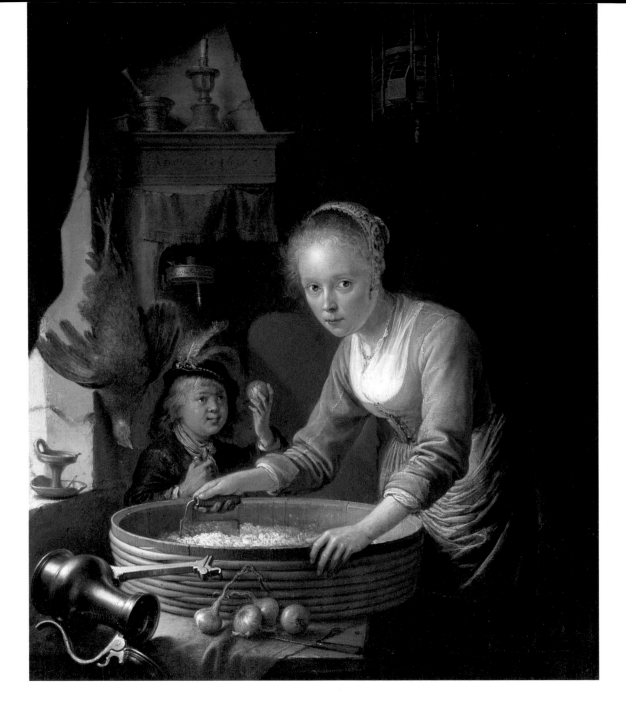

Gerrit Dou (1613-1675), Young Woman Chopping Onions.
The Royal Collection, Her Majesty Queen Elizabeth II.

A Clash of Symbols

CHICKEN HUTSPOT,
IN THE SPANISH FASHION

BEEF HUTSPOT,
IN THE MANNER OF BRABANT

CHOPPING ONIONS would in itself be more than enough to account for the misery of this winsome young woman, but there may be other reasons for her distress. The empty birdcage, signifying loss of virtue, the sexual connotations of the onions and dead bird in the foreground, the suggestive shape and position of the jug on its side, have all been read as indications of a more poignant cause for grief.

The mind boggles! The girl is busy making a *hutspot* (see page 91), of which the main ingredients, apart from meat, are as we all know, onions and carrots. Some wine from the bottom of the jug never came amiss in a stew either. Maybe the birdcage was where she kept the garlic. It is as well to remember that most genre paintings had for their owners an immediate appeal, which we too can grasp, and other layers of meaning, clear to them but obscure to us, which, though fun to tease out, can tie us up in quite pedantic knots.

The *hutspot* means more to the Dutch than Irish Stew or Mother's Apple Pie does to us. It is a potent symbol of the courageous Republic's overthrow of a hated foreign tyrant. One version of the story is how, in 1574, when the Spanish seige of Leiden seemed, after terrible months, to have an unshakable stranglehold, the leaders of the community decided to open the sluices and flood the rich acres of reclaimed land. The sea, so painfully vanquished, came surging back and routed the enemy. The Spanish garrisons fled. Leiden was free. A small boy crept into the deserted camp and there, still simmering on the dying embers, was a cauldron of stew. An abandoned *hutspot*.

This is celebrated in Leiden every year on October 3 with dancing in the streets and communal feasts of bread and herring. Families cook *hutspot* and invite friends for some real "Fatherland food," symbolizing the plain fare and heroic virtues of the Republic, eulogized by Simon Schama as "ruminative humanism" on a plate, neither mean nor lavish, "the perfect way to sanction abundance without risking retribution for greed."

In fact, it now seems that the identification of *hutspot* with Leiden did not happen until the late eighteenth century when some antiquary resurrected the story and made a picturesque folk legend of it. The noble *hutspot* itself, in a remarkable state of preservation, is lovingly exhibited in the Lakenhal Museum in Leiden, and local restaurants compete with different versions of the recipe.

Chicken Hutspot, in the Spanish Fashion

For six people:
1 free-range chicken, cut into pieces
1 cup white breadcrumbs
Marrow from a marrowbone, or butter
Ginger, cinnamon, saffron, sugar, and salt to taste
Lemon peel, in slivers
1 cup dates, stoned and chopped

Cook the chicken pieces in water or stock made from the carcass until tender, then add the breadcrumbs and seasonings, together with the dates and lemon peel, and simmer for about half an hour, until the flavors have amalgamated.

Use butter instead of bone marrow, if expedient.

A medieval Arab recipe and ingredients, filtering into Holland by way of Spain, did not seem too alien in a cuisine with access to a worldwide spice trade and an international tradition of richly spiced dishes. Even the innovative new cookery books contained many recipes in this older tradition.

54

Beef Hutspot, in the Manner of Brabant

For six people:
2 lb. (1 kg) shin and skirt of beef,
 cut into thumb-sized pieces
2 medium-sized onions
Salt, pepper, and mace for seasoning
Fresh ginger, peeled and chopped
1 cup chopped parsley
1 cup butter

Simmer the beef and onions in a little water until the meat is almost done. Add the spices and ginger and cook until the meat is tender. Stir in the parsley and butter and serve hot.

A variation on this, described as "in the Spanish Manner," uses lamb or veal instead of beef, omits the ginger, and thickens the stew with egg yolks and lemon juice before adding the parsley and butter.

Pieter Aertsen (1507/8-1575), The Meat Stall. *The stark realism of this butcher's shop* (overleaf) *dominates the composition, relegating the image of the Holy Family on the flight to Egypt to the background, behind the flayed ox head and the herrings in the shape of a cross. Licentious behavior at the table on the far right, behind the hanging carcase, may remind us of sin and redemption, but the "violently observed parts" of slaughterhouse and delicatessen are a rich source of information about meat products and their uses. Offal, the products of blood and milk, the utilization of every possible extremity, are shown here, interesting in their own right. University of Uppsala, Sweden.*

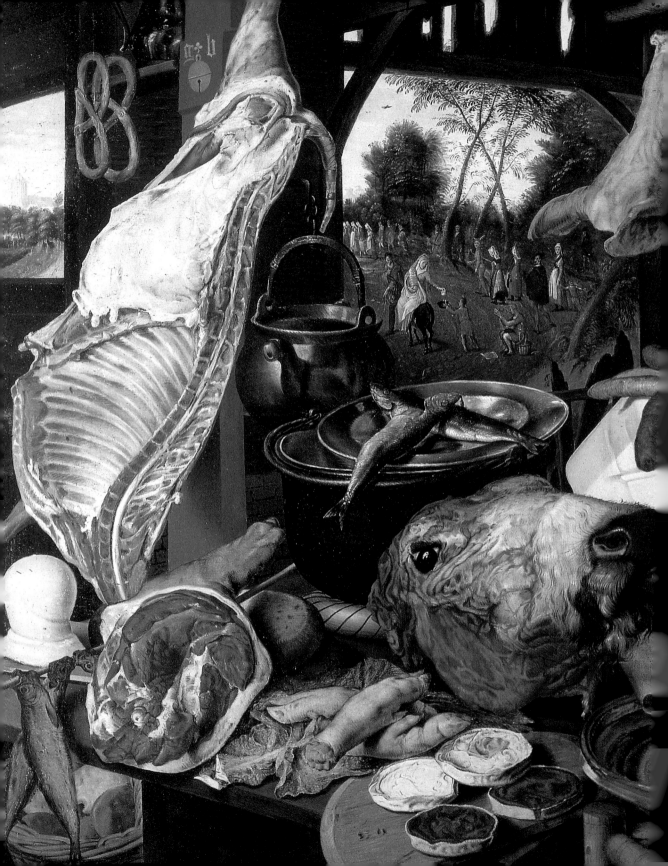

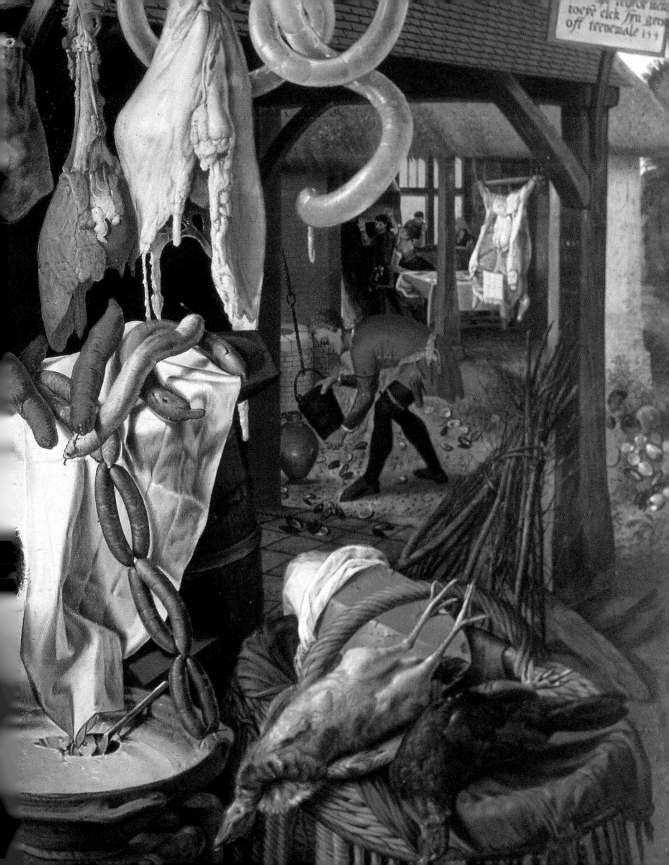

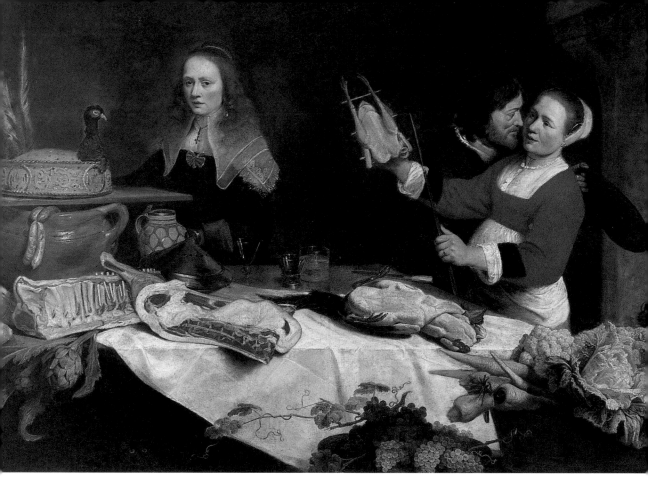

Kitchen Scene, *attributed to Samuel Hofmann (c. 1596-1648). Simplicity and artifice juxtaposed—the fresh young kitchen maid and her uninhibited handling of the expertly trussed chicken and her enthusiastic admirer, contrasted with the elaborately dressed, decorous mistress of the house and the equally elaborate and artificial pie, a ceramic imitation of a complicated pastry raised pie with the peacock's head and tail feathers emerging from holes in the lid, stiff and rigid. On one side of the canvas are the earthy vegetables of the kitchen garden; while on the other, the more exotic artichoke alongside the almost embroidered appearance of the stuffed loin of veal, the whole composition unified by the tendrils of the vine, symbol of both unbridled fecundity and married fruitfulness. Musées Royaux des Beaux-Arts, Brussels.*

The Great Pie

SPICED MEAT & FRUIT PIE

VEAL & LEMON PIE

CHICKEN PIE

RUSTIC MEATBALLS

THE MAGNIFICENT PIES which have pride of place in so many still-life paintings are in a long and noble tradition. From medieval times the pie has been a convenient form of portable food—a rich mixture of meat, dried fruit, and aromatics suitable for travelers, banquets, or lavish hospitality.

The principle of encasing meat and other delicacies in a strong, not necessarily edible, container and cooking it slowly so that the heat gently penetrates the contents, without any contact with liquid, produces a dry-cooked dish, which, if not exposed to air, will keep rather well for quite some time. But once broken into, pies deteriorate rapidly, so the rich creations depicted in the paintings, spilling their contents over gilt plates and snowy tablecloths, might imply dissolution as a result of profligacy, extravagance teetering on the brink of decay, a self-indulgent society decaying from within.

Spices and sugar, with their useful preservative qualities, together with densely flavored dried fruit and sufficient fat to keep the mixture from drying out, make a basic filling. We know this well in our Christmas mince pies, in which the fat, good beef suet, is important, but the meat has vanished over the ages. Try adding some finely chopped beefsteak to homemade mince pies or some of the sweet filling to a steak and kidney pie, remembering that the distinction "sweet/savory" is relatively recent.

But as well as being a basic, rather crude, food for keeping, the pie could be a luxury dish, with a fragile, crisp crust and an

exquisite filling of delicate meats, chicken, and veal, with the contrasting flavors and textures of artichoke hearts, asparagus, sweetbreads, bone marrow, hard-boiled eggs, lambs' tongues, sliced pickled lemons, tiny forcemeat balls, crystallized fruit, cinnamon, rosewater, and aromatic wines.

❧ Spiced Meat & Fruit Pie ❧

This recipe from *The Well-Informed Cook* reflects the old ways; pungent with spices and dried fruit, like many a medieval creation.

2 lb. (1 kg) rump steak, cubed
8 oz. (250 g) prunes
1 lb. (500 g) currants
½ cup pine nuts
1 teaspoon chopped green ginger
1 teaspoon each of crushed cloves,
 cinnamon, and nutmeg
1 tablespoon dried (or frozen)
 bitter orange peel (see page 91),
 softened in "small beer" (try Guinness)
Dry white wine
Meat stock
Salt, pepper, and sugar to taste
Butter to taste
Rich shortcrust pastry (see page 41)

Cook the meat until tender in half the wine and your usual aromatics (bay leaves, garlic, etc. see page 91).

Soak the dried fruit in the rest of the wine until soft. Then add it to the meat, together with some of the meat juices, the peel, and the spices and cook a little more. Enrich with butter. Thicken if necessary with breadcrumbs, ground almonds, or the sieved yolks of 2 hard-boiled eggs.

Taste and add salt, pepper, and sugar to get a rich, vibrant flavor. Tip into a deep pie dish and cover with the pastry, making a few holes for the steam to escape. Decorate the pie with elegant swirls of pastry leaves, flowers, and curlicues or leave it plain. Bake in a moderate oven for about 45 minutes or until the crust is golden. Eat hot or cold.

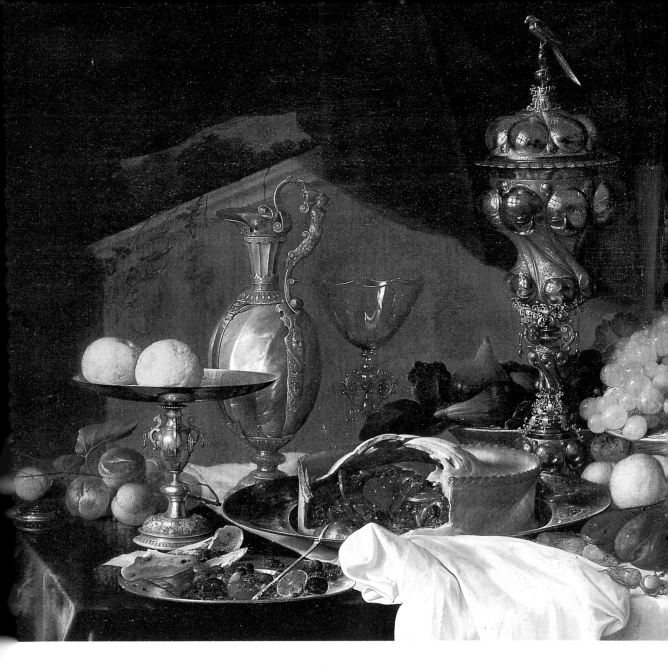

This detail from a still-life by Jan Davidsz. de Heem (1606-1684) shows a typical pie with a filling of meat, dried fruit, spices, and sliced lemon, similar to our traditional filling for mince pies. Palais du Louvre, Paris.

🦋 Veal & Lemon Pie 🦋

1 lb. (500 g) leg of veal, finely chopped
½ cup veal fat, finely chopped
1 lemon; half of it thinly sliced, the rest chopped
Salt, pepper, nutmeg, and mace to taste
2 egg yolks
Butter to taste
Verjuice, lemon juice, or white wine
 vinegar (see page 92)
Rich shortcrust pastry (see page 41)

Mix all the ingredients together except the sliced lemon. Line a pie dish with a layer of pastry, tip in the meat mixture, and finish with the lemon slices and generous lumps of butter. Cover with a pastry lid and bake in a moderate oven for 1 hour. Eat hot or cold. If hot, make a sauce with meat stock thickened with egg yolks, butter, and verjuice. (Lemon juice or a very little fine white wine vinegar may be used instead of verjuice.)

 A little chopped parsley or marjoram makes a pleasant addition to the flavorings.

🦋 Chicken Pie 🦋

For four to six people:
1 free-range chicken, jointed
8 oz. (250 g) small sausages, cooked
8-10 meatballs (see page 34), cooked
8-10 fresh artichoke hearts, cooked
1 lb. (500 g) asparagus (tips only), cooked
1 cup shelled and cooked sweet chestnuts
Salt, pepper, nutmeg, and mace to taste

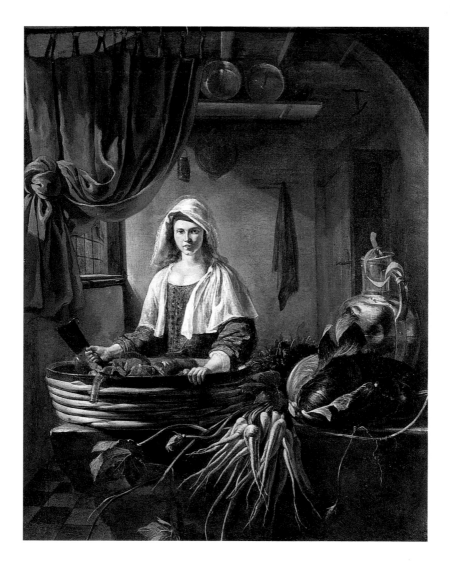

This resolute young woman, chopper in hand, is hacking up offal, perhaps at pig-killing time, when every bit of the animal was made use of, from snout to tail. Here the liver and lungs are being prepared, possibly for this meatball recipe. Her modest demeanor, together with the attendant symbols of unblemished virtue and high rank, might just be a reference to the story of Judith and Holofernes. W. van Odekercken, Kitchen Still-Life. *Private Collection.*

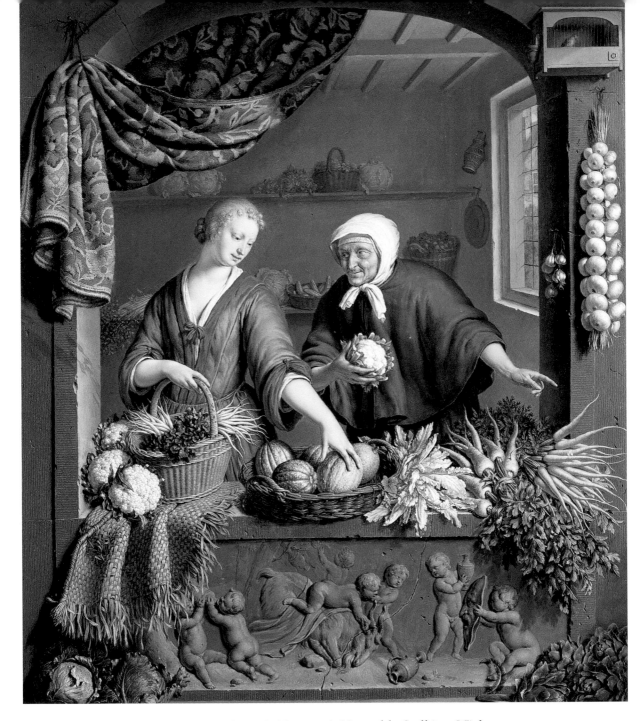

Willem van Mieris (1662-1747), Vegetable Stall in a Niche.
The Wallace Collection, London.

The Vegetable Kingdom

WINTER SALAD WITH CABBAGE

GREEN BEANS

SPINACH WITH SOLDIERS

COOKED VEGETABLE SALAD

GREEN PEA SOUP

THE COUNTRY HOUSE garden supplied the kitchens of the rich, but people in the cities enjoyed a profusion of fruit and vegetables from the market gardens and orchards which flourished on the outskirts. The fertility of reclaimed land and the efficient network of canals for getting the fresh vegetables to market brought produce in from even farther afield.

There is a wealth of information for agricultural historians in the art of the period—market and kitchen scenes and still-life paintings—which, read alongside documentary evidence, from household accounts to records of local market taxes to poetry and books of emblems, give a vivid account of the riches of the market gardens of the Netherlands. Locating all these treasures is a fascinating task, and a frustrating one. A cornucopia of luscious striped marrows, blowsy pink and green cabbages, radiant vermillion and yellow carrots, tumbled together with freshly shelled broad beans, overflowing baskets of cherries, apples, pears, mulberries, trailing sprigs of iridescent red currants, and luminous gooseberries will as like as not be cataloged "Still-Life with Parrot," after some wretched bird cowering morosely on a plinth in the top left-hand corner. Art historians tend to live on a higher plane than those of us who cheerfully grovel on kitchen floors or sift through the contents of middens, as Dr. Zeven discovered when he embarked on his pioneering studies of vegetables in art. The first sighting of a new strain of radish embedded

in a familiar Bible story, or lovage roots, scrubbed and ready for the *hutspot* (see page 91), lost amid the heavy moral overtones of a scene of low life, however, are some of the rewards of this magnificent obsession.

When Giacomo Castelvetro tried to convert the English to healthier eating habits, he sent for vegetable seeds from his friends in Holland, part of an international network of botanists and horticulturalists busy exchanging specimens and plants whose botanical passions were equaled by their gastronomical enthusiasms. Castelvetro picked up recipes as well as seeds and plants on his travels in Europe.

Winter Salad with Cabbage

Shred a hard-hearted cabbage as finely as possible with a sharp knife and dress with good wine vinegar, olive oil, garlic, salt, and pepper.

Green Beans

Broad beans had been around in Europe since Roman times, but the tender, edible pods of *Phaseolus vulgaris* from the New World—once called "Turkish" (exotic) beans but now called green beans—were a novelty which soon became an abundant crop. They are still sold in markets with a bunch of savory, the "bean herb."

Cook green beans in a little water until they are almost done and the water has evaporated. Top up with a little good, concentrated meat stock, and finish cooking with a lump of butter, some chopped parsley or savory, and salt and pepper.

🎋 Spinach with Soldiers 🎋

1 lb. (500 g) per person
Butter
Salt, pepper, nutmeg, mace, and garlic to taste
1 slice of good white bread for each person,
 cut in strips and fried golden in butter

Wash the spinach leaf by leaf in running water and toss dry.
Cook in a heavy pan, covered, so that it goes limp in its own
moisture. Strain off any liquid. Put the dry spinach in a pan with
plenty of butter, and season. Stir gently on a low heat, absorbing
as much butter as appropriate.

 Serve hot with the strips of fried bread standing up in the
spinach like soldiers in a green meadow.

🎋 Cooked Vegetable Salad 🎋

Cook, separately, some or all of the following, until tender:
 Green beans
 Chicory root
 Beetroot
 Purslane
 Shredded red or green cabbage
 Hop shoots
 Elderberry shoots
 Onion
 Garlic

Serve tepid with oil and vinegar, salt, and pepper. The original
recipe suggests a little brown sugar as well.

Green Pea Soup

This traditional recipe is a descendant of the medieval stews or porridges of pulses and any available aromatics, roots, herbs, spices, and meat. Although time-honored versions of this recipe can solidify into a somewhat rigid dogma, it is agreeable to be pragmatic and use what comes to hand. The important thing is to retain the distinct flavors of the ingredients, in particular the fresh earthiness of the peas.

1 lb. (500 g) green split peas
1 1/2 lb. (750 g) piece of uncooked ham
2 or 3 Toulouse pork sausages
1 Dutch smoked boiling sausage
1/2 lb. (250 g) fatty *pancetta* or *spek* (see page 92)
2 cups chopped celery root (celeriac)
4 cloves garlic
1 large onion, chopped
1/2 cup chopped parsley
1/2 cup chopped lovage leaves
Salt, pepper, and nutmeg to taste

Cook the piece of ham and the *spek* or *pancetta* in water with bay leaves and cloves. Take them out and strain the stock. Let it cool and remove the fat, reserving it to add as a seasoning if you like.

Pick over the split peas and soak them overnight. Strain them and simmer gently in stock from the ham. Halfway through cooking add the onion, celery root, and garlic. Half an hour before serving, add the raw sausage and the boiling sausage. Keep tasting all the time, and don't put in any salt until toward the end, as there may well be enough in the ham and sausages.

When the peas are almost done, and it's up to you whether to have them whole or mushy, add the cooked ham cut into pieces, the *spek* cut up small, and the green herbs. Adjust the amount of stock to get either a rich soup or a purée full of tasty bits of meat. Enrich with additional fat or bits of butter and eat hot.

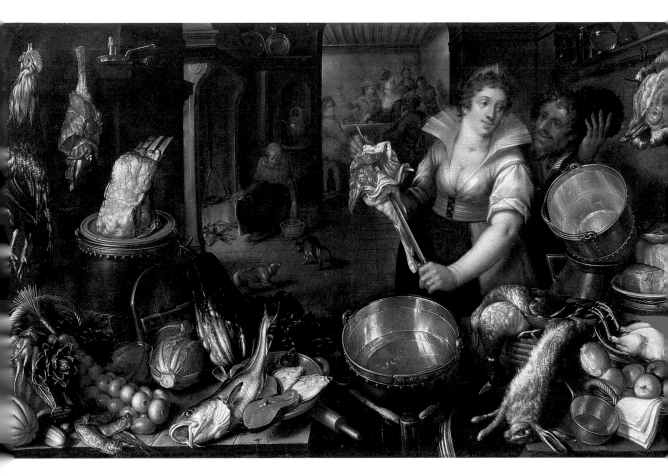

Cornelis Jacobsz. van Delff (1571-1643), Kitchen Scene.
On the left of this well-stocked kitchen are some of the vegetables appropriate to the green pea soup. Virginia Museum of Fine Arts, Richmond, Virginia, gift of Miss Ellen Blair.

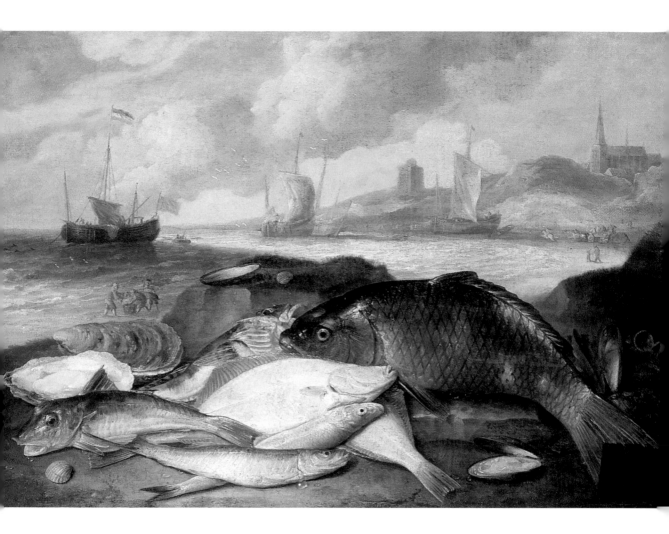

Joris van Son (1623-1667), The Four Elements: Water.
Private Collection.

The Mountains of Holland

GRILLED FISH WITH CAPERS

BAKED FISH

SALMON IN WINE

SALT COD WITH PARSNIPS

SAUCE FOR CRAB OR LOBSTER

HAKE WITH GINGER

BAKED FISH IN A LEMON SAUCE

OVER THE centuries generations of brilliant Dutch engineers have, with dogged tenacity, tamed two of the four elements—earth and water—which have been hammered, battered, and flattened into shape. As one's plane circles down toward Schiphol Airport the sixty-foot barges sit, in the intricate network of Amsterdam's dockland, like so many docile minibuses on a parking lot. It is impossible to tell water from tarmac in the ordered geometry of this rational environment.

But the wildness of the wind, useful but uncontrollable, creates the vast, romantic cloudscapes which are the mountains of Holland. Its mountaineers are painters. They celebrate the huge, anarchic turbulence of space and light which towers above this flat and orderly land. Seascapes are full of wind and weather, and shopping for fish becomes a heroic trek to the beach, where the freshly landed catch is waiting for customers under a storm-tossed sky.

How to cook it? With fine fresh fish the simplest way is best—grilled, baked, or fried, with the lightest seasoning of butter, herbs, or something sharp, such as lemon or bitter orange juice (see page 91), or an unsweetened fruit purée.

❧ Grilled Fish with Capers ❧

1 medium-sized trout, herring,
 or mackerel for each person
1 teaspoon salted capers per fish,
 soaked to remove the salt
 (capers in vinegar are not as good)
2 teaspoons chopped parsley
2 tablespoons flour
Salt, pepper, and crushed mace to taste

Clean, wash, and scale the fish. Score the flesh diagonally with a sharp knife. Roll in the seasoned flour. Grill until golden and serve with the capers strewn over it, and a squeeze of lemon.

❧ Baked Fish ❧

Allow 6-8 oz. (200-250 g) of cod
 or haddock per person,
skinned and filleted
2 cups white breadcrumbs
1 cup butter
Salt, pepper, and crushed mace to taste
Grated zest of 1 lemon

Mix the breadcrumbs with the seasonings and coat the fish with half the mixture. Lay the fillets in a buttered ovenproof dish and cover with the rest of the crumbs. Dot generously with butter and bake in a hot oven for as short a time as possible, 10 to 15 minutes, depending on the size of the fish.

If cooked too long the fish will exude its juices and make the topping soggy; further cooking soaks up the liquid, but the fish ends up fibrous and dry. So have the courage of my convictions and take it out of the oven the moment the muscle proteins coagulate. Eat hot with a little lemon juice.

Jacob Foppens van Es (1596-1666), Lunch Table with Fish. Musée des Beaux Arts, Nancy.

Salmon in Wine

A dry white wine or a good-quality white wine vinegar is suitable for this dish.

For six people:
2-3 lb. (1-1 ½ kg) salmon tail, scaled
2 cups water
2 cups dry white wine
Mace, nutmeg, salt, and pepper to taste
Garlic and bay leaf are optional
1 cup breadcrumbs
Butter to taste

Simmer the water, wine, and aromatics (see page 91) together. Put in the fish and poach it gently until done, maybe 30-40 minutes. Take it out. Reduce the cooking liquid if necessary, strain, and thicken with the breadcrumbs and butter.

Remove the fish from the bone and lay the pieces gently in the sauce. Serve hot.

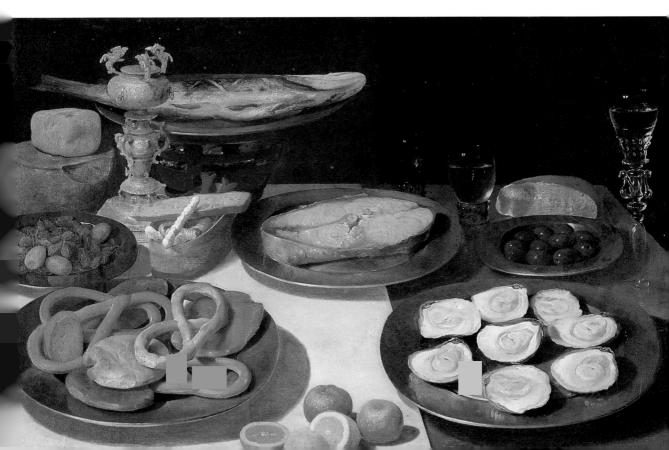

Salt Cod with Parsnips

For four people:
2 lb. (1 kg) salt cod
2 lb. (1 kg) parsnips, peeled (see page 92)
 and sliced into thick slices
Bay leaves, salt, pepper, and nutmeg to taste
Butter
Chopped parsley
Rice flour

Rinse any loose salt off the fish and soak for 12 to 24 hours in water. Change the water once or twice. Put the fish into a pan, just cover it with fresh water, and bring gently to the boil. Turn off the heat and leave to soak until soft. Remove skin and bones from the cod, keeping the pieces as big as possible.

Meanwhile, cook the parsnips in very little water until soft.

Butter an ovenproof dish. Roll the fish pieces in seasoned rice flour and put in the dish with the parsnip chunks and any cooking juices. Strain over a little of the fish's cooking liquid and dot generously with butter. Season with the aromatics. Cook in a moderate oven until golden and bubbling, about 1/2 hour. Do not overcook.

Serve with mustard, fresh bread, and a green salad.

A pleasant alternative is to use leeks instead of parsnips. Pitted green olives are good addition to either version.

Sauce for Crab or Lobster

1/2 lb. (250 g) unsalted Dutch butter,
 cut into small cubes
1 cup chopped parsley
Salt, pepper, mace, and nutmeg to taste
Lemon juice

Soften the butter in a basin over a pan of hot water. Have a bowl of iced water ready to cool it down if necessary. Beat it with a whisk, adding the lemon juice drop by drop until it thickens to a creamy sauce and season with the crushed spices.

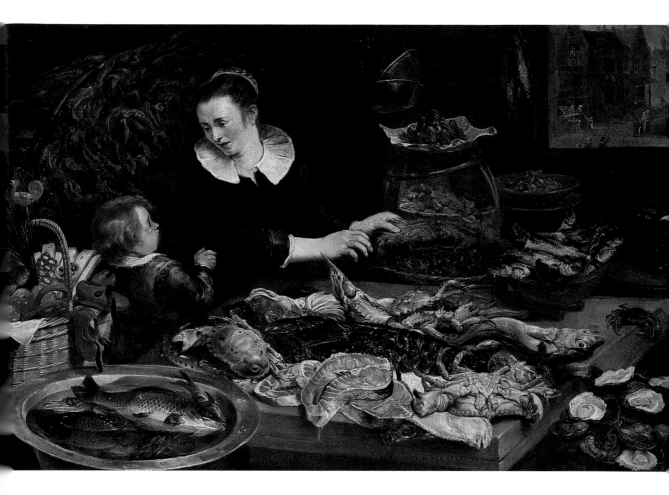

Frans Snyders (1579-1657), The Fishmonger. *The small boy, with his little red shoes, like freshly boiled lobsters, importunes his busy mother, with her piles of freshly cooked shrimp and shellfish, newly opened oysters, prepared pickled herrings, slices of salmon, and a bowl of live freshwater fish. He may get some fruit or fancy bread from the basket on the left. Pushkin Museum, Moscow.*

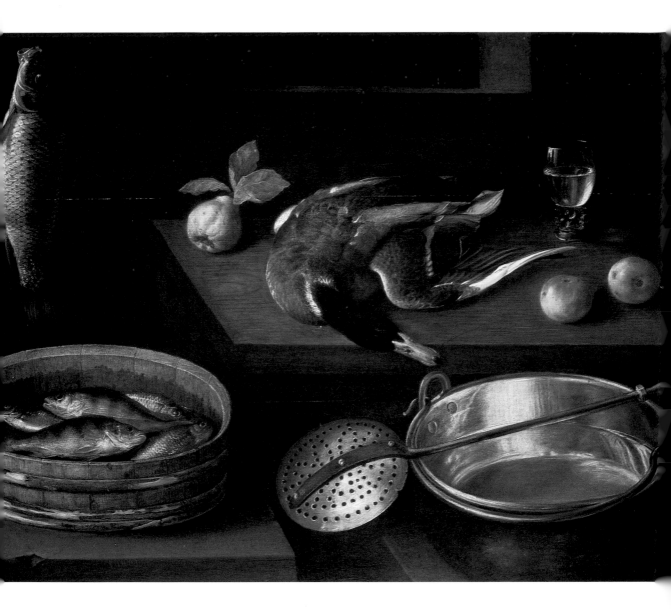

Sébastien Stoskopff (1597-1657), Tub of Perch, Cauldron, and Strainer on a Ledge. *Stoskopff's haunting subjects have a numinous presence, unencumbered by any symbolic or didactic purposes. Private Collection.*

Hake with Ginger

For four to six people:
A large, whole hake, cleaned and beheaded
A finger-length piece of fresh ginger,
 peeled and grated
Salt, pepper, 2 or 3 whole blades of mace,
 bay leaves, and garlic to taste
Butter

Bake the fish in the oven until just done, with the mace and bay leaves. Take care not to overcook. Peel off the skin and remove the exquisite opaline white flesh from the bone. Lay the pieces in a serving dish and keep warm.

Strain any cooking juices into a small saucepan and add the grated ginger, a little garlic, and plenty of butter. Whisk together and add any juices which may have run from the fish. Pour over the hake and serve nice and hot, decorated with the pieces of mace.

Baked Fish in a Lemon Sauce

This method was specified for pike in *The Well-Informed Cook* but works well with halibut fish, tuna, or swordfish. Bake a 2-lb. (1-kg) piece of fish in a hot oven until just done. Do not overcook.

For the sauce:
1 fresh lemon, chopped
1 cup dry white wine
1 tablespoon grated fresh ginger
4 or 5 cloves
½ teaspoon saffron
Salt and pepper
1 cup butter

Simmer the lemon, wine, spices, and seasonings together. Let it cool, then beat in the butter until the sauce thickens.

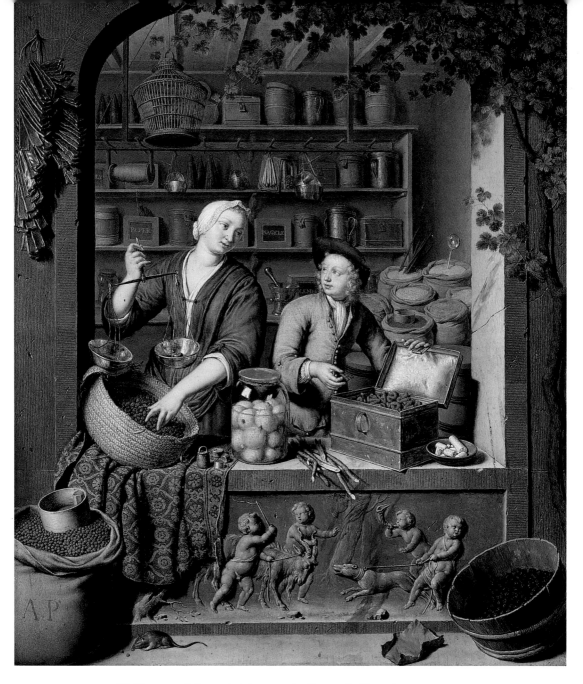

Willem van Mieris (1662-1747), Grocer's Shop in an
Alcove, *1732. Besides dried fruit, ginger, cloves, pepper, sugar,
and a jar of pickled lemons, this shop displays a box of alphabet
cookies. Private Collection.*

St. Nicholas:
Patron Saint of Literacy?

SPECULAAS COOKIES

SPECULAAS SPICES

COOKIES WITH ALMOND PASTE

OLIEBOLLEN

POFFERTJES

SOME OF the joys of winter in the Netherlands are the chocolate letters given to children on December 5, the eve of Saint Nicholas's day, one for each initial of their name. They are made in molds of traditional design, with a recent concession to digital characters, and since every letter must weigh the same, for commercial reasons, the constraints on the designer are somewhat trying—to make a "J" the same weight as an "M" is a tall order.

The use of letters as edible magic goes back a long way. It is said that at the end of the harvest the ancient Nordic gods were offered specially baked bread in the form of runes, spelling out propitiatory messages. The Catholic Church smoothly annexed such deep-rooted pagan practices and handed them on to Christian saints. Santa Claus, Saint Nicholas, is wafted on a boat all the way from Spain with his white horse, on which he cavorts over the rooftops of the Netherlands, administering rewards and punishments for good and naughty children (and sailors), including cakes, cookies, and breads specially baked for the celebration of his feast day, December 6. Among these used to be cookies made in the shape of letters of the alphabet, potent with the magic power of The Word, conveying literacy in edible form to the young and underprivileged.

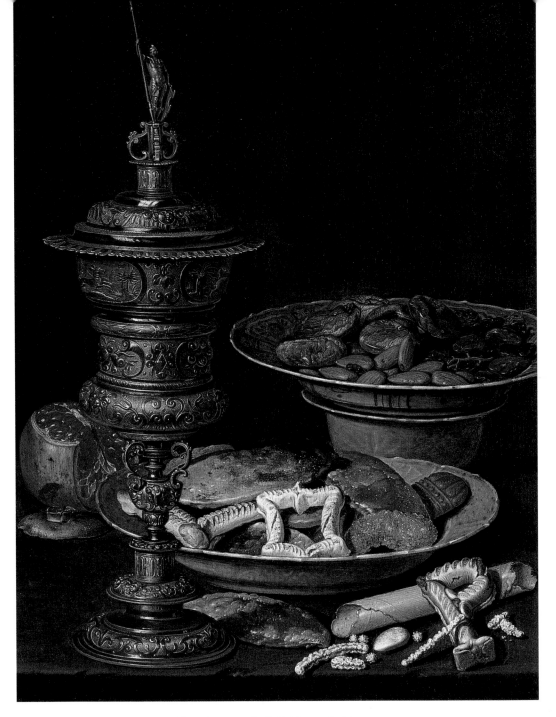

Clara Peeters, Still-Life, *probably 1612.*
Private Collection.

Clara Peeters introduced into many of her paintings intricately wrought cookies in the form of a voluptuous "P" fashioned with all the skills of contemporary engravers. It is doubtful if a sweet tooth spurred her on to heights of confectionery comparable with her skilled brushwork. Pondering over this with a magnifying glass, trying to puzzle out how the cookies could have been made, I had that uncomfortable feeling of being scrutinized myself. It seemed a good idea to switch on all the lights, make a cup of tea, and turn on the radio. But the creepy feeling remained. Then I saw her. A ghostly Clara reflected in the polished bosses of a silver gilt goblet. Clara, with her palate and easel, nebulous but very real. I felt compelled to go at once into the kitchen and bake a propitiatory batch of *speculaas* cookies.

❧ Speculaas Cookies ❧

8 oz. (250 g) white flour
6 oz. (185 g) butter
4 oz. (125 g) sugar
1 egg, beaten
Salt to taste
2 tablespoons *speculaas* spices (see below and page 92)
Grated peel of 1 lemon
4 oz. (125 g) flaked almonds
Cream for mixing
$\frac{1}{2}$ teaspoon each of bicarbonate of soda
 and cream of tartar

Mix the flour, sugar, and spices together and work in the cut-up butter. Add the almonds and lemon zest and moisten with just enough cream and egg to make a firm dough. Wrap in film and chill well.

Roll out and make into shapes with cookie cutters or genuine patterned *speculaas* molds.

Put them on a buttered baking sheet and cook until golden, about 20 minutes in a moderately hot oven.

Speculaas Spices

Specially ground *speculaas* spices can be bought in Holland in the weeks before Christmas, but it is easy to grind the following mixture at home:

> 1 tablespoon each of cloves, nutmeg, and mace
> 1 teaspoon peppercorns
> 1 teaspoon cardamoms
> 1 finger length of stick cinnamon

Cookies with Almond Paste

> *Make an almond paste with:*
> 8 oz. (250 g) ground almonds
> 1 egg
> 4 oz. (125 g) sugar
> 2 oz. (60 g) whole, blanched almonds
> Rosewater

Mix everything together and moisten with rosewater.

Roll out half the *speculaas* cookie mixture (see page 83) and lay it on a buttered baking sheet. Roll out the almond paste and lay this on the layer of dough. Roll out the rest of the cookie mixture and put on top of the almond paste. Cut diagonally with a knife to make lozenge shapes, putting a blanched almond onto each one. Bake as above.

Peter Binoit (active c.1611-1624), Still-Life with Letter Cookies (above). Both serifed and sans serif (see page 92) letters are here enshrined in the pastrycook's art, prefiguring the decorated letters of nineteenth-century typefounders by over two centuries. Groninger Museum, Groningen.

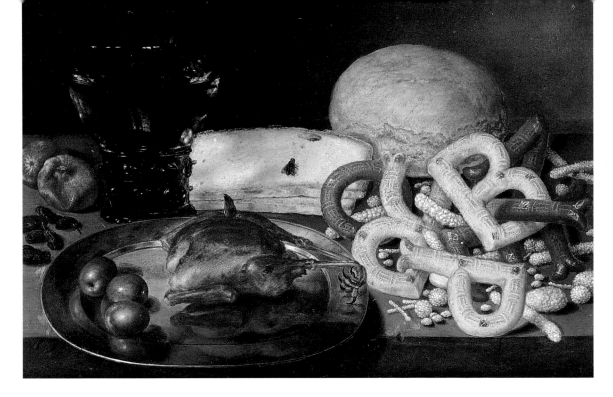

🍂 Oliebollen 🍂

2 cups flour
1 packet dried yeast (or Easybake yeast)
½ cup butter
1 cup mixed dried fruit
1 tablespoon *speculaas* spices (see pages 84 and 92)
1 large eating apple, peeled and chopped
½ cup slivered almonds
1 egg
Beer and milk for mixing
Salt and sugar to taste
Oil for deep frying

Make a batter with the flour, spices, salt, sugar, yeast, and liquids. Stir in the softened butter, fruit, and nuts and knead well. Cover and leave to rise to double its size.

Punch the dough down and fry big spoonfuls of the mixture in hot oil. The doughnuts should turn over, with an encouraging prod, taking about 3 or 4 minutes for each side. Serve sprinkled with icing sugar.

Poffertjes

These mini-pancakes, light and puffy, are excellent fairground and holiday food. The best I have ever eaten were made by an elderly Turkish gentleman, cheerfully integrated into the huge, polyglot open-air market in The Hague.

The light, almost liquid batter is poured into the tiny oiled depressions of a large cast-iron pan, cooked fast over a high heat, turned once, and served with icing sugar and a lump of butter.

> 1 cup flour
> 1 egg
> Beer and milk to make a light batter
> Salt, pepper, and spices to taste

Whisk all the ingredients together and leave to rest for an hour. If you do not have a genuine cookie pan use an ordinary frying pan. But it will not be the same as the street version—icing sugar in your socks, melted butter all over your shoes, and a nice east wind to cool the wickedly hot little *poffertjes*.

(Overleaf) *Protected from the wind by a tent improvised from a sail, an old woman cooks pancakes over a pot of coals, ideal as handwarmers and instant energy for the decorative skaters. Esaias van den Velde (c.1591-1630),* Winter Landscape, *1616. Private Collection.*

Epilogue:

The Shape of Things to Come . . .

❧

A CHERUB blowing bubbles is an obvious symbol of the vanity of earthly pleasures, but his plump little belly prefigures the sad fate that the newly introduced tubers, seen smoldering in an unearthly glow on the right, were to inflict on the gastronomy of northern Europe. The potato had a baleful influence on the cuisine of the Netherlands from which it never recovered. A century after this early sighting in Italy, it replaced bread as the staple food of Holland. Brilliance effaced by sludge—reflecting perhaps the change in political and economic status of Holland in Europe. Food from the New World was to bring a splash of vivid color to the tables of Italy and Spain, but cast a grayish blight over the Dutch gastronomic scene.

The influential cookery schools of the late nineteenth century, with their authoritative publications, sanctified stodge for the best possible reason, to provide nutritious and economical food for the laboring poor. And so the need for color, excitement, and fantasy that so many of us assuage through food was to find other forms of expression with the Dutch. The bright, intricate patterns of textile and embroidery lavished on the Byzantine intricacy of the costumes of the different regions, provided the sparkle and brilliance lacking in the cooking. And the manic Dutch sense of humor still spices life in unexpected ways.

The warmth and wholesomeness of the food paintings of the Golden Age still resonate in family cooking and the unbroken traditions of superb cheese and preserved fish; and the markets of the Netherlands teem with a splendid variety of potatoes, whose many virtues should not be dismissed lightly. The "white root" which I have translated as parsnip in the recipe on page 76, adapted from *Volmaakte Grond-Beginzelen der Keuken-Kunde*, of 1758, may well be an early sighting of that best of all food combinations—potatoes and fish, a happy note to end on after all.

Giulio Carpioni (1613-1679), Soap Bubbles, *1650.*
Seventeenth-century botanists associated the potato with
flatulence, so perhaps the bubbles are a gentle warning against
overindulgence. Museo Civico, Vicenza.

Glossary & Notes

AROMATICS: herbs, spices, fruit juice, or peel used as flavoring.

BITTERBALLEN: were traditionally served with bitter beer, and now accompany *jenever*. A soft inside, of cooked meat in a smooth sauce, is coated in breadcrumbs, deep fried, and served hot with mustard.

BITTER ORANGE: or Seville orange, is a sour, acid orange with aromatic peel, used mostly for marmalade but an excellent substitute for lemon in cooking or salads.

BROODJE: a white bread roll or bun in which a variety of good things are served. It is represented in many still-life paintings in various shapes and sizes, but the continuity with the past is broken by the poor quality of modern industrial bread. It is advisable to make one's own.

GREEN HERRING, GROENE HARING, NIEUE HARING: a young herring in which the roe is not fully developed, which is gutted as soon as it is caught and lightly cured in brine. It should be eaten the next day, with chopped raw onion. Thanks to refrigeration green herring can be served year-round, but in the past it was a delicacy available only in May, just before the young herring produces its roe.

HUTSPOT: a meat and vegetable stew, originally made with a wide variety of ingredients but now with beef, onions, carrots, and potatoes. It is traditionally associated with celebrating the "Relief of Leiden," when the hated Spanish invaders were routed, on October 3, 1574.

JENEVER: Dutch gin is a lower percentage proof than London gin, but it should nevertheless be treated with respect. It comes in two kinds, *Oude* and *Jonge*. The flavors vary, depending on the manufacturer, but the main one is juniper berries, the essential oils of which are distilled, along with other plant fragrances, into the spirit. It is more pleasant drunk neat than mixed with things.

MAATJES, MAATJES HARING: a lightly cured herring but with a longer life than the green herring. Vacuum-packed and refrigerated or frozen, it is now widely available, but lacks the charm of the former.

MEDLAR: *Mespilus germanica*, a hardy fruit of the Rosaceae family, which is palatable only when slightly rotted, or bletted.

NEMATODE: a worm the parasitic species of which is found in raw fish and can occasionally survive human gastric juices and go on to create mayhem in the intestinal tract. Freezing destroys it.

OLIEBOLLEN: spicy doughnuts with dried fruit, traditionally made in the home for family Christmas celebrations; now a popular street food.

ONTBIJTJE: usually translated as a "breakfast piece," this still-life of relatively humble things—cheese, herring, bread, and beer—depicted the basic elements of a simple meal at any time of day, and so might well be called a "snack-scape."

PANCETTA: Italian dry-cured streaky bacon.

PARSNIPS: were common in seventeenth-century Holland, but were ousted by that other "white root," the potato, and are now considered rare and exotic vegetables.

POFFERTJES: little yeast dough mini-pancakes made in the depressions of a cast-iron cookie griddle pan; a favorite street food, cooked to order and served with butter and a powdering of sugar.

PRONK: a still-life of blatantly luxurious items—lobster, exotic fruit, expensive silver and glass; an ostentatious display of wealth and conspicuous consumption.

SANS SERIF: the name given to a letter with cut-off terminations to the strokes from which it is formed; often associated with modern movements in design but in fact can be traced back via neo-classical letterforms to Etruscan and Greek inscriptions. Appears in various molded and shaped cookies in seventeenth-century still-life paintings.

SPECULAAS: a corruption of "Santa Klaus," a spicy cookie made for Saint Nicholas's Eve. The shops are full of excellent *speculaas* spice mixtures, usually a combination of the following: black peppercorns, cinnamon, allspice, cloves, and cardamom seeds. Traditionally, these cookies were made in decorative molds, now collectors' items, with designs sometimes originating in a pre-Christian past.

SPEK: cured pig fat, with a hard texture and density of flavor which make it ideal for larding lean meat or adding to stews.

VERJUICE: the juice of unripe fruit, used fresh or fermented as a pleasantly astringent condiment or dressing to meat, fish, or vegetables. In seventeenth-century Holland it would have been made from sour apples or grapes.

Acknowledgements

My editor, Treld Pelkey Bicknell, and I have been enthusiastic about this project for a long time, but this book would never have happened without the generous help of many friends: Françoise Berserik took care of me while I was researching in the Netherlands, with warmth and books and food and *jenever* and breezy walks at Scheveningen; Fred Meijer dealt with my queries with exemplary patience; Joop Witteveen was generous and constructive; Dr. Zeven at the Plant Research Institute at Wageningen discovered the picture for the Epilogue and shared his insights into vegetables in art; Gerard Unger inspired the quest for chocolate letters; Hendrik de Nie helped with research.

The following also helped in many ways, and I thank them all: Ancilla Antonini of Index, Mien and Hermanus Berserik, Paul Breman, Derek Johns, John Lane, James Mosley, Gerrit Noordzee, Jill Norman, The R & B Partnership, Layinka Swinburne, and Tessa Trethowan of Christie's Images.

Illustrations

The author and publisher wish to thank the following for permission to reproduce copyright material: *Christie's Images* for frontispiece (Mike Fear) and pp. 13, 30, 46, 50, 63, 72, 78, 80, 86/87, and back cover; *Scala* for p. 5 (German National Museum), 36 (Mauritshuis, The Hague), 61 and front cover (Palais du Louvre, Paris), and 77 (Pushkin Museum, Moscow); *Wallraf-Richartz Museum, Cologne* for p. 9 (© Rheinisches Bildarchiv, Cologne); *Birmingham Museums and Art Gallery* for p. 11; *Frans Hals Museum, Haarlem* for p. 14; *Gemäldegalerie Alte Meister, Dresden* for p. 18; *Museum Boymans-van Beuningen, Rotterdam* for p. 21 (Tom Haartsen); *The Burrell Collection* (© *Glasgow Museums)* for p. 23; *Museum of Fine Art, Ghent* for p. 24; *Courtesy of The Berkshire Museum, Pittsfield, Massachusetts (Gift of Zenas Crane)* for p. 27; *Mauritshuis, The Hague* for p. 28; *Collection of The Montreal Museum of Fine Arts* for p. 35 (Brian Merrett MMFA); *Rijksmuseum, Amsterdam* for pp. 39 and 44; *The Wallace Collection, London* for pp. 40, 48, and 66; *Courtesy Charles Roelofsz Gallery, Amsterdam* for p. 51; *The Royal Collection © Her Majesty Queen Elizabeth II* for p. 52; *Uppsala University Collections, Uppsala* for pp. 56/57; *Musées Royaux des Beaux-Arts de Belgique, Brussels* for p. 58 (Speltdoorn); *Virginia Museum of Fine Arts, Richmond, Virginia, (Gift of Miss Ellen Blair)* for p. 75; *Richard Green* for p. 82; *Collection Groninger Museum, Groningen* for p. 85 (John Stoel, Haren); *Index* for p. 90 (Museo Civico, Vicenza). Page 43 is *Reproduced by Courtesy of the Trustees of The National Gallery, London.* Page 32 is from a *Private Collection* (Sotheby's). Page 65 is from a *Private Collection* (Courtesy S. Nystad, Art Dealer, The Hague).
The Index was prepared by *Angie M. Baxter.*

❦ Bibliography ❧

Alpers, Svetlana. *The Art of Describing: Dutch Art in the Seventeenth Century.* Chicago, 1983.

Bergstrom, Ingvar. *Dutch Still-Life Painting in the Seventeenth Century.* London, 1956.

Burema, Lambertus. *De Voeding in Nederland van de Middeleeuwen tot de Twintigste Eeuw.* Assen, 1953.

Castelvetro, Giacomo, trs Gillian Riley. *The Fruit, Herbs, & Vegetables of Italy.* London, 1989.

Clifton, Claire. *The Art of Food.* London, 1988.

Davidson, Alan. *North Atlantic Seafood.* London, 197?

Decoteau, Pamela Hibbs. *Clara Peeters.* Luca Verlag, 1992.

De Jong, E. et al. *Dutch Still-Life Painting.* Auckland, New Zealand, 1983.

De Nie, Henrik, W. Food, *Feeding and Growth of the Eel, (Anguilla anguilla L.) in a Dutch Eutrophic Lake.* Wageningen, 1988.

Forbes, W. A. *De Oudhollandse Keuken.* Bussum, n.d.

Fromentin, Eugène. *The Masters of Past Time.* Oxford, 1981.

Ghent, Museum of Fine Art, (Exhibition Catalogue). *Joachim Beuckelaer, het Markten Keukenstuk in de Nederlanden.* 1550-1650, Ghent, 1986.

Limburg Stirum, Corry Countess van. *The Art of Dutch Cooking.* New York, 1961.

Meijer, Fred G. *Stillevens uit de Gouden Eeuw.* Rotterdam, 1989.

Posthumus, N. W. *Nederlandse Prijsgeschiedenis.* Leiden, 1964.

Rose, Peter, G. (Translator & Editor). *The Sensible Cook, Dutch Foodways in the Old and the New World.* Syracuse, New York, 1989.

Schama, Simon. *The Embarrassment of Riches.* London, 1988

Schneider, Norbert. *The Art of the Still-Life.* Cologne, 1990.

Segal, Sam. *A Prosperous Past.* The Hague, 1989.

Segal, Sam. *Jan Davidsz de Heem en zijn Kring.* The Hague, 1991.

Sluiters, Karen. *A Little Dutch Cookbook.* Belfast, 1991.

Sutton, Peter. *Masters of Seventeenth-Century Dutch Genre Painting.* Philadelphia, 1984.

Van't Veer, Annie. *Oud-Hollands Kookboek.* Utrecht/Antwerp, 1966.

Vroom, N. R. A. *A Modest Message as Intimated by the Painters of the "Monochrome Banketje."* Schiedam, 1980.

Wentinck, Charles. *Eten en Drinken in Beeld.* Utrecht/Antwerp, 1979.

Witteveen, Joop, (editor). *De Verstandige Kock.* Amsterdam, 1993.